Wisdom With
Understanding
is Better
Than Rubies

LIFE IN BRONZE

NUMBER SIXTEEN:

Joe and Betty Moore Texas Art Series

LIFE IN BRONZE

LAWRENCE M. LUDTKE, Sculptor

Amy L. Bacon

TEXAS A&M UNIVERSITY PRESS

College Station

This paper meets the requirements of ANSI/NISO z39.48–1992 (Permanence of Paper).
Binding materials have been chosen for durability.
(∞)

LIBRARY OF CONGRESS CATALOGING-IN-PUBLICATION DATA
Bacon, Amy L., 1969–
 Life in bronze : Lawrence M. Ludtke, sculptor / Amy L. Bacon. — 1st ed.
 p. cm. — (Joe and Betty Moore Texas art series ; no. 16)
 Includes bibliographical references and index.
 ISBN-13: 978-1-60344-943-4 (cloth : alk. paper)
 ISBN-10: 1-60344-943-4 (cloth : alk. paper)
 ISBN-13: 978-1-60344-966-3 (e-book)
 ISBN-10: 1-60344-966-3 (e-book)
 1. Ludtke, Lawrence M., 1929–2007. 2. Sculptors—Texas—Houston—
Biography. 3. Bronze sculpture, American—20th century. I. Title.
II. Series: Joe and Betty Moore Texas art series ; no. 16.
 NB237.L84B33 2013
 730.92—dc23
 [B]
 2012044401

To Larry's beloved Erika

*and to the men and women of our armed forces
who serve and defend our great nation
with valor, integrity, and honor*

CONTENTS

A color gallery follows p. 56.

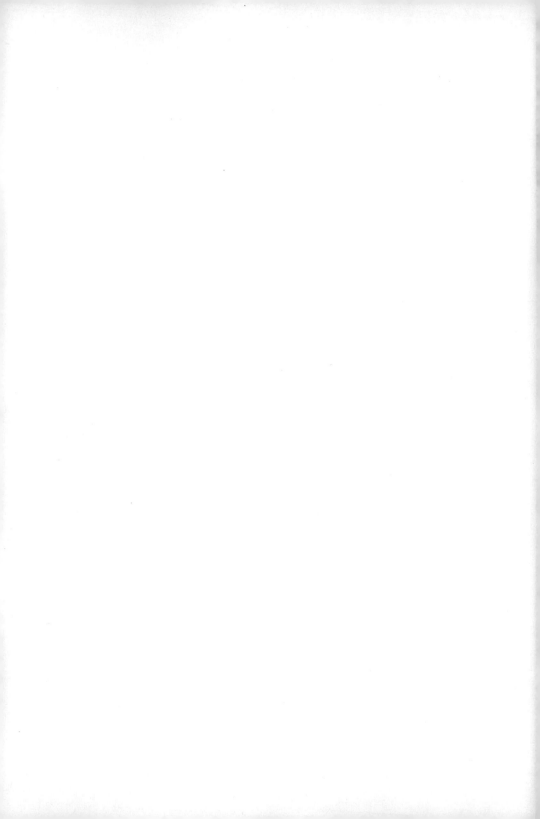

REFLECTIONS FROM TWO FRIENDS

LAWRENCE M. "LARRY" LUDTKE had a tremendous love for people and especially for working with students from diverse disciplines, helping them understand the importance of art and the uniqueness of sculpture. He possessed a unique capacity to represent and define that spark of human divinity in his subjects—in the cold, hard, and lasting medium of bronze. Larry's work clearly demonstrates why art is important to the self-understanding of our species and the values which make humans unique on this planet. Larry Ludtke was one of the few people, regardless of one's credentials, titles, or experience, who could explain the meaning and mission of art, with its beauty, timelessness, and spirit of life.

James R. Reynolds, April 2012

Letter read in 2007 at the memorial service for Lawrence M. Ludtke

I have had the privilege of knowing Larry for over thirty years. He was a man of integrity. Larry always did everything he promised to do—and more. Larry was one of our most prominent sculptors, and the quality of his work was exceptional! Larry created memorials for a number of our nation's finest military heroes. These memorials were labors of love for Larry. Some of these military heroes' statues were over twelve feet tall, because to quote Larry, "These men were bigger than life."

The soldiers' memorials included all the equipment and weapons that they carried in combat, including boots, rifles, backpacks, daggers, canteens,

ammunition, and unit insignia. When the families of these heroes, and fellow soldiers who had fought alongside them in combat, visited the memorials after they were in place, they were overwhelmed by the accuracy and attention to detail. Hundreds of thousands of military force members, soldiers, sailors, Marines, and Air Force pilots have been inspired by Larry's memorials.

Larry, you are a great friend, outstanding husband and father, and a role model for honor and integrity to all who had the privilege of knowing you.

The last line of the "Star-Spangled Banner" is a question—"O say does that star-spangled banner yet wave o'er the land of the free and the home of the brave?" As long as we have great patriots like Larry Ludtke, the answer will be a resounding YES!

H. Ross Perot, June 2007

IN 1991, I HAD THE PLEASURE of meeting Lawrence "Larry" Ludtke for the first time, when I was a senior at Texas A&M University. I was participating in the Memorial Student Center's Spring Leadership Trip in which students traveled to Houston for four days to visit museums, dine in world-class restaurants, attend performing arts presentations, and interact with successful A&M former students in business, politics, and law. My particular trip included a visit to the home and studio of the distinguished Texas sculptor to learn about the process of creating figurative sculptures. Given the size of his studio, half the students would visit with Ludtke while the other half were entertained alongside the pool by Erika Ludtke, his lovely wife. Then, after thirty minutes, the two groups would switch places.

I remember when driving up to the Ludtke home how amazed I was at the unpretentious house and its surrounding neighborhood. In my mind, a famous sculptor who had created commissions for Ross Perot, the CIA, SeaWorld, and the Jesse Jones family would definitely have a more grandiose home and studio. However, when I walked to the back of his house and into the studio, which looked as if it had once been part of the garage, I was transported to a different world—one filled with figures that elicited thoughts of Michelangelo Buonarroti, Auguste Rodin, Daniel Chester French, Gutzon Borglum, and others. I had just spent the prior summer in Italy through the Study Abroad Program of Texas A&M University and had experienced firsthand the epic marble sculptures such as Michelangelo's *David* and the *Pietà* in Saint Peter's

Basilica, as well as forms and figures of other classical sculptors, such as Dona-
tello (Niccolò di Betto Bardi) and Gian Lorenzo Bernini. Now, here I was,
standing in a studio in the center of Houston, Texas, listening to a man whose
ability to infuse life into his pieces was just as apparent as I had seen in the
works of those Italian masters.

Watching the six-foot, five-inch–tall man talk passionately about the pro-
cess of creating classical figurative sculpture, I could not help but be transfixed
by this southern gentleman. He was riveting as I listened to him explain the
process by which he brought figures to life through clay—the Old World tech-
niques, usage of Italian master sculptor Pompeo Coppini's plastilina clay that
had been handed down to him, the lost-wax mold process, and his amazing
attention to every minute detail. It was no wonder that the humanity in each
of the pieces he highlighted for our group was abundantly clear. Yet, with such
deft skill, what shone through even more were Ludtke's integrity, his humil-
ity, and his down-to-earth demeanor. Accompanied by a firm handshake, his
warm, genuine smile touched my soul. At that time, little did I know that our
paths would cross again sixteen years later.

When given the opportunity to write the life story of Larry Ludtke, I could
not have been more thrilled. Yet it was also a bittersweet moment. I knew at
the beginning of the project that Larry had very little time left as he was heroi-
cally battling cancer. I would spend three days a week during the entire month
of April 2007 interviewing Larry for hours at a time. We started our discus-
sions with the very beginning of Larry's life, his childhood, his minor league
baseball days, his meeting Erika, and the wonderful family memories. I would
listen intently as he discussed his early days of sculpting and the amazing jour-
ney he had taken to become one of America's premier sculptors. His ability to
recount every detail and narrate such good stories was astonishing considering
that his health was failing. Yet Larry boldly told me his life story, and, in turn,
I believe he was given a remarkable gift of reflection in making the final jour-
ney of his life. The endearing relationship we developed in such a short period
of time was inexplicable, yet I knew that we had been brought together for a
much greater purpose.

After Larry's death on May 4, 2007, I began in earnest to conduct additional
research and oral interviews with those who had played instrumental roles in

Larry's life. I began a five-year journey of my own, researching what I believe is the extraordinary life story of one of our nation's leading figurative sculptors. Ludtke's life trajectory is phenomenal, as he was born to a middle-class Houston family, played minor league baseball with the Brooklyn Dodgers, found a love for classical sculpture through the love of his wife, and tried his own hand at sculpture. Largely self-taught, he committed himself to his art while balancing a sporting-goods sales job and a family. Ludtke not only inherited the clay of Pompeo Coppini but also continued in the same classical tradition of sculpting that is at risk of being lost as faster, more modern techniques take hold among newer generations of sculptors. Like Coppini, he was gifted at bringing out not only the human form hidden in the clay but also the spirit of humanity that lay within each figure.

Each artist has his or her own version of living the American dream, but Ludtke's has not been fully explored until now. This narrative is an attempt to present a unique glimpse into the life and art of a nationally renowned sculptor whose works are located throughout Texas and the United States. I believe that Ludtke's diverse body of commissioned works—ranging from monumental heroic pieces and religious images to bas-reliefs—all provide an opportunity to see just how an artist's life experiences can ultimately become interwoven in his or her art.

Very few of Ludtke's works were given formal titles; the majority of his pieces are identified by the name of a specific individual or a general description. As a result, there is potentially significant variation in how these pieces might be listed. For the sake of consistency, throughout this book all of Ludtke's works are identified using italics, particularly in the "Major Sculptures" section and in the appendix.

I cannot begin to thank Erika Ludtke and James R. "Jim" Reynolds enough for the "once-in-a-lifetime" opportunity to write this book. Their tremendous assistance and unending faith in me to effectively capture the essence of Larry Ludtke were invaluable. They constantly provided resources, names, photographs, documents, and other information vital to this project. Members of the Ludtke family, especially Larry's son, Erik Ludtke, were wonderful in their willingness to support this project and share their thoughts, personal memories, and recollections with me any time I requested. Ludtke's dear friend and

model for several of his works, Jaroslav Vodehnal, not only provided stories and insight but also took beautiful photographs of most of the primary sculptures featured in this book. I certainly do appreciate all these efforts to assist me in my research.

During the course of four years, I interviewed numerous colleagues, foundry employees, patrons, and friends of Ludtke. Everyone I interviewed had a positive response to the project, and their collaboration was vital to enriching Ludtke's story. I especially want to thank H. Ross Perot for the time he personally spent with me to talk about his relationship with Ludtke and the various pieces he commissioned. It was a privilege and an honor to interview such an amazing man and patriot. I also want to extend my sincere appreciation to Paul J. Springer, who transcribed all the interview tapes and did a magnificent job. His painstaking efforts were essential to the book's creation and completion.

I also owe special thanks to Joseph A. Pratt, Cullen Professor of History and Business at the University of Houston, who, as my former graduate professor, provided a great deal of guidance and advice at the beginning of the project. Numerous friends and others have extended their support and encouragement during the five years of this project. They include Jane Bailey, Pam Reynolds, Marlene Bacon, Mary Ann and Bill Shallberg, George and Liz McMillin, Allen and Janet Flynt, Dallas Shipp, Fraser and Amy Landreneau, Dania Tanguis, Pam Martin, and Stephanie Stock. To these and many others who go unnamed, I am extremely grateful.

The publisher, Texas A&M University Press, has been a pleasure to work with on every aspect of this endeavor. I want to express my sincere gratitude to the Press staff for their guidance and willingness to work with me again after publishing my previous book, *Building Leaders, Living Traditions: The Memorial Student Center at Texas A&M University*. I deeply appreciate the support of director Charles Backus, Mary Lenn Dixon, Thom Lemmons, Gayla Christiansen, and all those whose dedication makes it an outstanding academic press.

I could never have attempted this second book project had it not been for the love, support, and encouragement of God and my family. My parents, Bobby and Sue Martin, have always been my biggest supporters, with an amaz-

ing conviction in my ability to succeed at whatever I set my mind to do. Without fail, they stepped in whenever I needed them to help me—whether that was reading through drafts or babysitting when I needed to write or make trips to Dallas and Santa Fe for interviews. Of course, I owe my dearest daughter, Ellie, so much for allowing me the time to work on this project and for enduring countless hours of me working on the computer, deep in "book mode." She is my biggest cheerleader and my most valuable treasure. My husband, Robert, a chemical engineer by profession but an editor at heart, gave me so much love and support during this project. He endlessly proofread drafts, offered ideas and suggestions, and, most importantly, believed that I could tell this story with the integrity, attention to detail, and genuineness befitting Larry Ludtke and his art.

LIFE IN BRONZE

Introduction

The Human Body is the mirror of the soul,
and it is from this fact that it derives its greatest beauty.
AUGUSTE RODIN

THROUGHOUT THE AGES, human fascination with self-imagery has been a powerful force, transcending generations upon generations of different cultures and races. Whether through crude portrait drawings seen on cave walls or the first sculptural representations of the human form in stone, *Homo sapiens* has sought a medium with which to portray the human body and its essence. The human figure has remained the central theme of art, as it encapsulates the entirety of human existence and experience. It is the one form with which all humankind totally identifies—physically, emotionally, intellectually, and spiritually.[1]

The Bible presents God as the creator of the human body, shaped in his own image (Genesis 1:27). The Creation story places God as the first sculptor, crafting the human form from the very basic material of dust, yet breathing life into his creation. And so it is with those who create figurative sculpture—they "breathe life" into their figures, which become art. Figurative sculpture is an art form that not only presents its viewer with a body to admire but also manifests all the beauty, dignity, and mystery that comes with the human condition. A figurative sculptor is the conduit through which these characteristics and emotions are able to burst forth from clay, marble, stone, or wood.[2]

At first glance, a tall, strapping Texan who once played professional baseball seems an unlikely source of such masterpieces. Yet that is precisely the description of Lawrence M. "Larry" Ludtke. Ludtke was a Houston sculptor best known for the dozens of extraordinary bronze likenesses he created—three US

presidents, countless legendary Texans, decorated US military heroes—as well as numerous other commissioned portraits and figurative sculptures, many of monumental size. With his uncompromising attention to detail, anatomy, and proportion, Ludtke was a disciple of classical sculpture at a time when many sculptors and artists had departed from the figurative tradition to follow such trends as abstraction and modernism. Yet Ludtke found his place by pursuing the Old World styles and techniques of sculpting clay figures, and he perfected an ability to capture the human spirit of his subjects. He created images that presented a strong sense of movement and realism. Ludtke's unique talent for capturing the distinct personalities of those he depicted resulted in sculptures that truly reflect the humanity of the men and women whose deeds, hearts, and minds have had a profound impact on our nation—Sam Houston, Ronald Reagan, Lyndon Baines Johnson, Gen. James Earl Rudder, John F. Kennedy, Babe Didrikson Zaharias, Brig. Gen. James Robinson Risner, Col. Arthur D. "Bull" Simons, Gen. William J. "Wild Bill" Donovan, Darrell K. Royal, and numerous other historical figures. His work can be seen at some of the most prominent institutions across the United States, including the United States Air Force Academy; CIA headquarters in Langley, Virginia; the Gettysburg National Military Park in Pennsylvania; the United States Naval Academy; the Ronald Reagan Presidential Library; the National Cowboy & Western Heritage Museum in Oklahoma City; Johns Hopkins University School of Medicine in Baltimore; Saint Mary's Seminary in Houston; Texas A&M University; Rice University; the University of Texas at Austin; Fort Bragg, North Carolina; and MD Anderson Cancer Center and Jones Hall for the Performing Arts in Houston.

Ludtke was elected a full member of the National Sculpture Society (NSS) in 1974, at the same time as Georgia's famed Jekyll Island sculptor, Rosario Fiore. Later, in 1981, Ludtke was recognized as a Fellow in the society, along with the renowned sculptor of western subjects, Glenna Goodacre. He was also named a Corresponding Member of the Royal Academy of British Sculptors.

By taking a closer look at his work, we can see how it represents an important part of our nation's figurative sculpture tradition. While the sculptors in Greece and Italy perfected the classical form of human sculpture over thousands of years, the art form of classical figurative and portrait sculpture even-

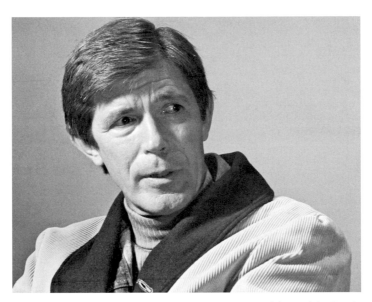

Lawrence M. "Larry" Ludtke, circa 1980. Courtesy of the Ludtke family.

tually found its way to the newly formed United States in the early 1800s. European-trained immigrant artists and sculptors were recruited to complete statuary decorations for such national monuments as the US Capitol in Washington, DC. Over time, American artists began to go to Italy to learn sculpture from the Italian masters and immerse themselves in studying the great statues of the ancient world. By the mid-nineteenth century, Paris had replaced Florence and Rome as the center for training artists, and Americans studied at the prestigious École des Beaux-Arts, France's state school for artists. With the United States' centennial celebration in 1876 came a movement to promote the human figure in sculpture displayed as part of public monuments, as well as in the design of important civic and private buildings—all with the purpose of enshrining America's principles, values, and history. This part of the American Renaissance, when the arts of painting, sculpture, and architecture came together in a great crescendo likened to the Italian Renaissance of the fifteenth and sixteenth centuries, saw a dramatic increase in figurative sculpture, particularly in civic art. It is within this context that we see portrait sculptures of our

nation's founders, statesmen, and heroes created in great numbers for state-houses, libraries, battlegrounds, national parks, universities, and other sites paying tribute to their legacies from America's past. There was a gradual departure from depicting these heroes in the neoclassical style; some of the early sculptures even represented figures from American history in the tradition and dress of Roman or Greek gods, an example being Horatio Greenough's *George Washington* (1840). Rather, the focus began to shift to a more naturalistic and dramatic style. Works such as Daniel Chester French's *Concord Minuteman* (1875) and Gutzon Borglum's *General Philip Sheridan* (1908) in Washington, DC, brought a "feeling of movement," as well as a "specificity of moment and timelessness," according to French art expert Michael Richman.[3]

In Texas, one sculptor who captured this same lifelike realism in his pieces, which greatly contributed to the state's civic and memorial landscape, was Pompeo Coppini. Coppini was an Italian-born sculptor who studied in Florence at the Accademia dell'Arte del Disegno under Augusto Rivalta. In 1896, he immigrated to New York and then came to reside in San Antonio in 1901. After spending some time in Texas and working on large commissions, he moved to Chicago and later New York and then returned to Texas, which became his permanent home. Coppini was a staunch advocate of classical figurative sculpture and abhorred modernism and abstract art. His masterpieces include the marble Alamo Cenotaph, which he sculpted in celebration of the Texas Centennial in 1939 and which sits in the center of Alamo Plaza and features the likenesses of Jim Bowie, Davy Crockett, James B. Bonham, and William Travis. This sixty-foot monument stands on the location where many believe the bodies of the heroes of the Alamo were burned. Coppini has dozens of great works throughout Texas, including the Littlefield Fountain at the University of Texas, the bronze doors of the Scottish Rite Cathedral in San Antonio, the statues of Jefferson Davis and other figures for the Confederate Monument on the capitol grounds in Austin, and countless others. His bronze statue of Gen. Lawrence Sullivan Ross, former governor of Texas and third president of Texas A&M University, is considered one of the most revered works on that university's campus. Coppini died in 1957, leaving his foster daughter and fellow sculptor Waldine Tauch to pass on his methods from the studios of his academy in San Antonio. Nearly a decade later, the

paths of Tauch and Ludtke crossed as he undertook to learn the art of sculpture from Coppini's protégé.[4]

At first glance, Coppini and Ludtke may seem to have had little in common. Coppini was a formally trained Italian sculptor at one of Florence's most prestigious academies, while Ludtke spent some time studying with Tauch but was primarily self-taught. Yet figurative sculpture has a way of transcending time and place, with intrinsic emotions, style, and techniques flowing from one sculptor's masterpieces and inspiring another. An enduring bond is established, and such is the case with Coppini and Ludtke. Ludtke followed the same classical tradition nearly thirty years after Coppini's heyday to become a leading figurative sculptor in his own right, exclusively using the very same clay from which Coppini formed his works of art. Both men were gifted at bringing to the clay not only the human form but also the extraordinary qualities that lay within a particular figure. In Ludtke's case, he conducted exhaustive research using numerous books, photographs, and interviews. He took all that he learned, visualized how to accurately express various character traits uncovered in his research, and then his mind and his hands were able to bring them to life in his sculpture. This gift of human realism is the true story behind each and every one of his sculptures. What is described in clay and captured in bronze ultimately represents not just his training and technique but rather a culmination of the life experiences and values of Larry Ludtke. To glimpse the essence of Rodin, one could just stare into his piercing eyes. To experience the monumental achievement of Mount Rushmore's Gutzon Borglum, one need only read of his energy and expansive personality. To appreciate Ludtke and understand how he became the sculptor of monumental heroes, historical figures, civic giants, and spiritual images, one must explore his early days, when he bent his fingers around the seams of a baseball and pitched a wicked fastball for the Brooklyn Dodgers organization. The days of being an athlete, a devoted husband and father, and an honest businessman and loyal friend to many all contributed to the kind of sculptor he became and the end product he produced. Indeed, he became a distinguished sculptor of many high-profile commissions for the US government, business magnates such as H. Ross Perot, and world-class universities and institutions, but at the end of the day, he wanted to be known simply as "Larry."

The narrative that follows shows how each of Ludtke's life experiences throughout his seventy-eight years shaped him into a respected man and one of his century's finest figurative sculptors. Most sculptors seldom receive the personal recognition they are due. Their works are displayed in parks, on plazas, and elsewhere outside, with passersby rarely taking that extra moment to glance at the sculptor's signature at the base of the piece. Their names are often omitted from any description accompanying the work. Photographs in newspapers or magazines might reveal a sculpture in the foreground or background, but rarely is the artist's name mentioned or credit given. If a magazine features a photograph of the majestic Lincoln Memorial, rarely, if ever, is Daniel Chester French's name listed as the sculptor of one of America's most famous treasures. Ludtke was never one who sought fame, fortune, or recognition for his sculptures. Most of his work was by commission only, and he never participated in the art show circuit. In fact, he created his sculptures because, as he put it, "I simply loved doing quality work."[5]

The featured pieces and accompanying vignettes displayed later in this book celebrate this quality and attention to detail, as well as offer recollections to further illuminate these works of art. All are united by a common thread. Ludtke wanted to draw the observer into a piece, to study the lines, the authenticity, the expression, and to ultimately connect with the subject. Ludtke's life presents a fascinating and unique glimpse into the mind and heart of a sculptor. His diverse body of work provides an opportunity to see how the artist's life experiences and character can ultimately become interwoven in the creation of his art.

Paintbrushes and Fastballs

LARRY LUDTKE TOOK great pride in the fact that he was a fourth-generation Texan and native Houstonian. Given that both Texas and the Bayou City have always been associated with innovation, a can-do attitude, perseverance, creativity, and an entrepreneurial spirit, it is easy to see the source of his pride and perhaps how these characteristics took shape in him. The building of the Houston Ship Channel, the oil boom of the early 1900s, and the subsequent development of refineries and related industrial facilities brought significant population growth and development to the city of Houston and its surrounding areas in the 1920s. Neighborhoods began to spring up throughout the city. One of the oldest communities in eastern Houston, known as Denver Harbor, housed many families who had left their rural homes in hopes of making a better life by finding work on the railroad, along the ship channel, and in the industrial companies. There among the modest residences were all the trappings of an American neighborhood in the 1920s—schools, churches, a drugstore, a fire station, and even a movie house. A man named Monroe Ludtke owned and operated a meat market in Denver Harbor, and on October 18, 1929, he and his wife Dorothy welcomed Lawrence Monroe Ludtke into this world. Although his mother refused to call him by any name other than Lawrence, "Larry," as he became known, was a typical young boy, drawn to the game of baseball. Whether playing the game in the street or in a nearby vacant lot, Ludtke recalled the daily "banging of baseballs off our neighbors' roofs." As a student at Jefferson Davis High School, Larry was an All-City pitcher

for the school's baseball team and got the opportunity to play in Houston's Buff Stadium, a sporting icon in the town. That eleven-thousand-seat stadium, which opened in 1928, was the home of the Texas League Houston Buffaloes, the minor league farm franchise for the Saint Louis Cardinals. Playing in the stadium gave the high school ballplayers a real sense of playing in the big leagues. As Ludtke remembered, "A lot of people came to watch high school baseball games because it was cheap entertainment. It cost too much to take a girl out to dinner, but you could take a date to the game and get some peanuts and popcorn."[1]

In addition to his fascination with baseball, Larry had an unusual artistic ability buried deeply within him. Ludtke recalled having the ability to draw and paint from a young age; he was always quite fond of sketching and doodling. As a twelve-year-old, he ended up winning a local newspaper drawing contest with his entry of a cowboy and horse. In high school, Ludtke's interest in art had a more practical aspect: "It was an easy subject." He took an oil painting class as well as a watercolor class. His first painting, done in oils and depicting a snowy landscape, was bestowed upon his girlfriend at the time and was quite unusual given that Larry had never seen snow. His inspiration for the painting? "I had a lot of white paint!" His first "commission" came in the form of painting the backdrop for the Jefferson Davis High School prom. As Ludtke recalled, he painted "lollipops, ice cream cones, flowers—all sorts of useless, sweet things."

While Ludtke's mother recognized that he had artistic ability, she "certainly did not expect him to find success in the field of art, but always thought he would be a ball player." Baseball filled Ludtke's days and had become an integral part of his life. After graduating from high school, Ludtke went to Texas A&M University (at that time known as the Texas Agricultural & Mechanical College) to play on the freshman baseball team. At a baseball camp in Houston, a scout named Harry McCurdy discovered him. McCurdy was a former big league catcher then scouting for the Brooklyn Dodgers organization. McCurdy invited him to demonstrate his pitching skills, so at a nearby clearing Ludtke threw the ball for the scout. "I didn't know how to throw much of anything, but I could throw really hard," recalled Ludtke, "or as my grandfather said, I looked like I was falling out of a tree when I pitched." McCurdy

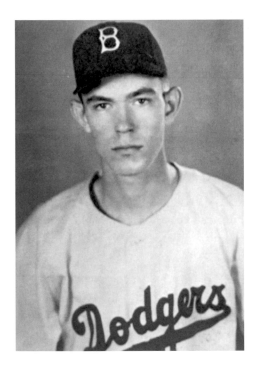

Ludtke in his Brooklyn Dodgers uniform when he first joined the minor league team in 1949. Courtesy of the Ludtke family.

must have liked what he saw because he offered Ludtke a contract. The following spring, in 1949, having withdrawn from Texas A&M, Ludtke went to a Dodger training camp in Maryland. It was an exciting and historic time to be involved in baseball. The Brooklyn Dodgers organization had chosen Jackie Robinson to break the color barrier in the major leagues in 1946. Robinson was signed to play first for the Montreal Royals and then, after a single season, was sent up to play for the parent club, propelling the Dodgers to win the National League pennant. Ludtke had become part of an organization making history.

At a salary of $150 a month, Ludtke thought he was living the dream, and he later recalled, "I was really thrilled to get it." He once said, "I would have paid them, just to get to play." He played for teams in Pulaski, Virginia; Sheboygan, Wisconsin; and Miami, Florida. Larry recalled having to stay in private homes most of the time, usually with a couple of other players, because the minor leagues were not known for their glamour or luxurious accommodations.

Occasionally, a few players even had to share beds. At their training camp in Vero Beach, Florida, Ludtke and his teammates found the living conditions less than ideal. The barracks of a decommissioned naval air station were used to house the players. They were old, crowded, and hot, and the food served there was "quite forgettable." However, none of this fazed Ludtke—he loved it. The camaraderie among the players brought him great enjoyment, and it was during his baseball days that Ludtke developed a strong work ethic and honed his ability to work with all types of people and personalities—traits that would certainly be needed later as a commissioned sculptor.

Ludtke recalled that, while he was playing for the Miami Sun Sox in the Florida International League, the team was the first to ever wear shorts on a baseball field. "While they worked out great in the heat, once you slid in them and endured a couple of bad 'strawberries,' that was the end of that." Ludtke's experience with the Miami Sun Sox proved to be even more rewarding due to the friendship he developed with the legendary Pepper Martin, one of the "Gashouse Gang" of the Saint Louis Cardinals of 1934. Labeled the "Wild Horse of the Osage" for his aggressive style of play, Pepper was a passionate player who commonly did belly flop slides into stolen bases and even threw at batters who bunted rather than throwing them out at first. Martin served as the manager of the Miami Sun Sox from 1949 to 1952 and began his first year by attempting to choke an umpire. As Ludtke recalled, Pepper was "just a wonderful, genuine character," one who typically wore the same thing every day—a baggy pair of pants with a zebra-stripe patterned shirt. "He didn't wear socks with his shoes, and he sure didn't wear laces in them, either," Ludtke said.

With the Sun Sox team, Ludtke never had a losing season. The *Miami Herald,* in one of its write-ups about a particular game against the Miami Beach Flamingos, cited the tremendous pitching and hitting of Ludtke: "Ludtke deserved an extra helping of credit as he rationed the Flamingos to three hits in the nine-inning nightcap, and drove in two runs to triumph, 4 to 1. Larry's pitching was brilliant, particularly in the second inning when it appeared his number was up. He started by walking Mort Smith[,] and two batters later the bases were jammed with Bob Morem singling and Chuck Ehlman drawing a walk. Smith scored on a fly ball, but then Ludtke bagged the next three outs in succession."[2]

During the Korean War, the army slightly altered Larry's baseball career by drafting him in 1952. Ludtke was stationed at Fort Sill, Oklahoma, where he trained with the artillery but was also able to play on the post's baseball team. At that time, all the big military bases, such as Fletcher Airfield at Clarksdale, Mississippi, and Randolph and Lackland air force bases outside San Antonio, had great baseball teams with a lot of big leaguers who were fulfilling their military service. When he mustered out in 1954, Ludtke returned to play baseball with the Dodgers' organization, being assigned to Mobile on the advice of Pepper Martin, who always thought Ludtke had the makings of a big-league pitcher.

In 1955, Ludtke received an invitation to pitch a season of winter ball for Al Kubski's Carta Vieja team in Panama, where he tested himself against the big leaguers who played down there. The Caribbean Winter League provided professional baseball players with a unique opportunity to play during the off-season. At the annual Winter Leagues Classic in Caracas, Venezuela, Ludtke pitched for Panama in what turned out to be a significant event because Puerto Rico's team included future greats Willie Mays and Roberto Clemente. Ludtke remembered that in this series, Mays did not have a good first outing, being unable to get a single hit in the first twelve times he was at bat. In the second game, when Mays came up against Ludtke and another pitcher, John Fitzgerald, he had little success. They did not allow him a hit.

By the late 1950s, Ludtke had started to grow weary of life as a baseball player. As he put it, "My baseball career kind of stalled. I never had a losing season, but I never had a great season. Finally, I just woke up one day and thought this is ridiculous. Here I am, sitting in a hotel room, having to wait three days to pitch again, and I'm just sick of it." Ludtke left the game with a career record of 56-27. He returned to Houston and finished his bachelor's degree in education at the University of Houston. In the meantime, Ludtke found a job as a sales representative for Riddell sporting goods, working the Texas Gulf Coast. Riddell was the primary maker of football helmets for collegiate and professional teams. While making a sales call at the Houston Oilers training camp, one of the trainers, Bobby Brown, asked Ludtke if he would design an oil derrick for their logo. At first he hesitated, saying, "I don't want to do that, I'm not involved in that at all. Just go down to any custom design place and have

it done." Brown, however, did not let up, and Ludtke recalled his reply being, "No, Larry, any damned fool can draw an oil derrick, so you might as well draw it." Ludtke proceeded to sketch out a derrick, and he gave it to the Oilers to use. His latent talent had briefly resurfaced, but it was not until 1959 that both his personal life and his artistic life joined to become one.

An Awakening

WITH BASEBALL NOW behind him, Ludtke focused on settling into his life as a sporting goods salesman for Riddell. The life of a salesman often led to great outings on the golf course, and for Ludtke a golf course was always a welcome sight. Every aspect of the game brought him great pleasure—being outside, basking in Mother Nature, and enjoying the company of good friends. One friend in particular decided to play matchmaker. During their golf games, this friend often told Ludtke that he wanted him to meet one of his clients, a young woman who could "out-talk you and just as sharp a girl as any guy could want to meet." In the fall of 1959, the details were settled for him to have lunch with this young German woman named Erika Lewandowski. He was to pick her up at her office, where she worked for Scandinavian Airlines (SAS Airlines). Erika clearly remembers the day when Ludtke walked into her office as she was sitting behind her desk. Her eyes kept going up, and up, and up as she thought to herself, "Oh, my God, it doesn't end, he is so tall!" The date was a success, for when Ludtke asked her out for the following weekend, she said yes.[1]

Erika was unlike any other woman Ludtke had met before. The petite native of Berlin was a survivor of the Allied bombings in World War II. She was seventeen years old when the war ended. She said, "My generation had nothing to do with the Third Reich, except we had to clean up the mess it made." Ludtke was captivated by the vivacious young woman and was not deterred one bit by the fact that she already had a young daughter, named Ellen. He found Erika to be intelligent, charming, and "the most beautiful girl I had ever

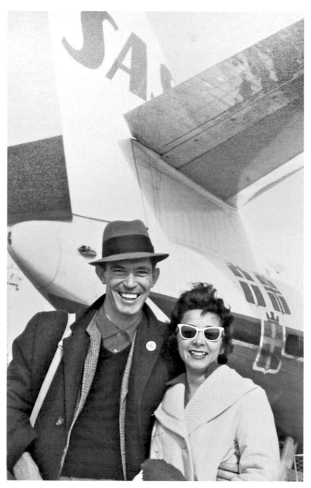

Ludtke and his wife, Erika, beside an SAS Airlines aircraft
during their honeymoon trip to Europe in 1960. Courtesy
of the Ludtke family.

dated." He remembered praying, "Dear God, don't let this beautiful woman
ever get away from me. This is the one." Erika herself was falling for the tall
Texan, noting that he was "a real gentleman, so kind and honest." She knew
their relationship was becoming more serious when Ludtke invited her to his
church to meet his mother, the pianist. This Denver Harbor church held a

special place in his family given that it was named the Ludtke Methodist Church. The Ludtke brothers financed the complete debt on the church, and it was named in honor of Larry's great-grandparents. Four months after they first met, Ludtke took Erika's hand in marriage in this same church, surrounded by family and friends.

A trip to Europe was the perfect honeymoon for the newlyweds, and it turned out to be an event that would shape their lives. The first thing Erika wanted to do was to have Ludtke meet her mother in Berlin, then travel to Switzerland, Italy, Turkey, and Greece. It was while touring the land of Michelangelo, Leonardo, and other Renaissance masters that, according to Ludtke, "a light went on." The couple went from museum to museum, viewing the paintings, the sculptures, and the architecture. Ludtke found himself mesmerized by the sculptures, especially the works of Michelangelo, which brought on intense emotions he never had experienced. The more sculptures he saw, "the more excited I got," recalled Ludtke. Erika recognized immediately that Ludtke presented a great natural understanding of depth and proportion, as well as a unique intuitive comprehension of the techniques and styles of the masters they were viewing. An overwhelming desire to become a sculptor began to take hold.[2]

A Guiding Hand from the Past

UPON RETURNING HOME from the honeymoon in Europe, Ludtke was determined to learn everything he could about sculpting while he worked for Riddell and then Spalding to earn a living. It was not an easy task to take on during this time when his young family was growing. Ludtke had adopted Ellen, Erika's daughter, and, soon after, the couple welcomed the birth of their son, Erik. Despite the increasing responsibilities, Ludtke found a way to balance his work, his family, and his desire to learn how to sculpt. He immersed himself in all things related to classical figure and portrait sculpture. He read hundreds of books and manuals about the art form and the process of casting bronze, as well as biographies of Michelangelo, Rodin, and others, including one sculptor with interesting Texas ties—Pompeo Coppini. Coppini, an Italian-born sculptor who had studied in Florence, came to the United States in 1896, at first living in New York. By 1901 he was residing in San Antonio. After spending some time in Texas and working on large commissions of historical figures, he moved to Chicago, New York again, and then permanently returned to Texas, where he produced some of the state's best-known monumental sculptures, including the Alamo Cenotaph and the Littlefield Fountain at the University of Texas. He was knighted by the king of Italy in 1931, receiving the title Commendatore of the Order of the Crown for his art contributions to the United States. He was an opponent of modernism and abstract figurative sculpture, stating that "any individual who dares to call himself an artist, but who uses graphic methods of distorting, elongating, dissect-

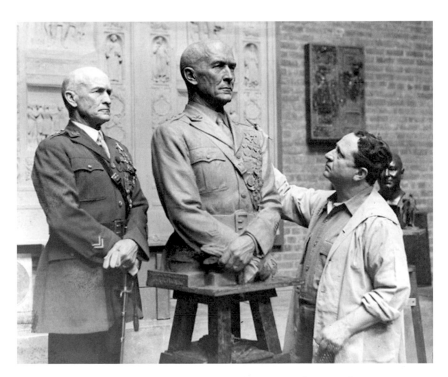

Pompeo Coppini, an Italian-born sculptor who came to the United States in 1896, lived in Chicago and New York but made San Antonio his permanent home. In Texas, he produced some of the state's most well-known monumental sculptures, including the Alamo Cenotaph. He is pictured here working on the full-size bust of Gen. Ulysses Grant McAlexander. Courtesy of the Coppini Academy of Fine Arts, San Antonio.

ing, or disfiguring God's given body, has in himself . . . a criminal."[1] In Ludtke's words, "Coppini was a magnificent sculptor and I could not scratch the mud off his boots."

Ludtke learned everything he could about Coppini. He read the sculptor's autobiography, *From Dawn to Sunset,* and decided that he would visit Coppini's old studio and academy in San Antonio. He had read that Coppini's protégé, Waldine Tauch, who also became his foster daughter, still lived and worked in Coppini's studio. Tauch had become an acclaimed sculptor herself. She was born in Brady, Texas, and showed such artistic promise as a teenager

that a women's group raised money in 1910 to send her to study with Coppini at the age of eighteen. She remained with the Coppini family until the sculptor's death in 1957, concentrating on her artwork and running the Coppini Academy in San Antonio. Ludtke showed up for a visit there one afternoon after telling her over the telephone how interested he was in sculpture, something he figured "she heard all the time." When he arrived, she was working on a twelve-foot figure. He recalled that after they talked for a little while, Tauch asked, "So you're really interested in sculpture?" Ludtke responded, "Yes, I think that I have an affinity for it and I think I can do it." Her next response threw him for a loop—she tore off a chunk of clay, handed it to him, and said, "Take this piece of clay, this block of wood, a couple of tools and go on and make me something." To say Ludtke was a bit apprehensive would be an understatement. He returned to his hotel room, his large hands delicately working all night on a model of his son, Erik. When he returned the next morning to show Tauch his piece, Ludtke recalled he had never been more nervous. "No three-and-two pitch ever meant as much to me," he recalled. She looked at it with a critical eye and said it looked as if Ludtke could indeed be a sculptor.

From that moment on, Ludtke never worked with any other clay than the kind Coppini handed down to Tauch in that time-honored tradition among sculptors of passing one's clay to his or her most promising student. Over the next couple of months, Ludtke would go back and forth to the studio, sometimes staying for a week, studying Tauch's technique and using this special clay that both Coppini and Tauch favored. It was an oil-based plastilina clay from Italy that Coppini had purchased following a bad experience using water-based clay on models that froze in his Chicago studio one wintry day and then "crumbled like flour." One of those models was for the statue of Lawrence Sullivan Ross at Texas A&M, and he had to start over from scratch. Coppini went on to use the plastilina clay to model nearly 130 pieces of sculpture in Texas and across the United States. Tauch used this clay exclusively and was intrigued when she saw that Ludtke could successfully mold with it. "The clay is very soft, almost mushy, and it is difficult to use," Ludtke pointed out, adding that "not many artists want to work with it because it requires delicate strokes and its odor is not that pleasant either." He bought blocks and blocks of this clay from Tauch so that he would always be able to sculpt with

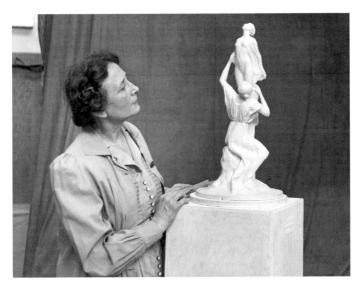

Waldine Tauch, Coppini's protégé and foster daughter, with her sculpture, *Clinging to Youth* (1945). Ludtke studied under Tauch, learning her technique as well as how to sculpt with Coppini's special clay. Courtesy of the Coppini Academy of Fine Arts, San Antonio.

it, although he remembered that Tauch warned him that "the clay is not what's going to make you a sculptor. The only thing that will make you a sculptor is lots of hard work and dedication."[2]

Tauch and Ludtke developed a unique friendship, and she appreciated his tenacity, commitment, and willingness to learn how to sculpt in the classical method. She taught him everything she had mastered, and Ludtke always believed that Tauch's encouragement and many hours of instruction were instrumental in setting him on the path to becoming a successful sculptor. She, in turn, knew sculpting was his future when she autographed Ludtke's personal copy of Coppini's autobiography and wrote, "May you rise to the top in this great art of sculpture and may you always enjoy it." Just as Coppini had done for her, Tauch ultimately bequeathed all the Coppini clay to Ludtke, her most promising student. With the Coppini clay in hand, little did he know the role it would play in creating future monumental figures throughout the United States.

Herman, Heroes, and Legends

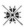

GIVEN THE INSTRUCTION and affirmation from Waldine Tauch, Ludtke thrust himself into sculpting, working extremely hard to gain more experience and to continue training in the classical techniques. However, sculpting was not going to pay the bills just yet, so Ludtke had to carefully balance his sporting goods job with his newfound passion. Erik remembers spending a lot of time in his dad's garage, where Ludtke practiced sculpture during the evenings and weekends and which later became his studio. While Ludtke worked on his sculpture, Erik would build model airplanes, and the two would just "enjoy each other's presence in utter silence."[1] It happened that one of Ludtke's contacts through his sporting goods job actually led him to his first commissioned work. While making calls in the San Angelo area, Ludtke heard through word of mouth that Ethicon, Inc., a subsidiary of Johnson & Johnson, wanted a large sculpture for its local plant. He contacted the company, speaking with a gentleman named Bob Wood, who would become a good friend. The two men immediately developed a good rapport, and Wood gave Ludtke the commission. Having never done a commission before, Ludtke was unsure of what to charge for such a large project, and when Wood asked him for a price, Ludtke remembered saying, "I don't know, I just want to do it. Let's just do it, and we'll worry about that later." He met with key individuals to determine what the sculpture would depict, and the discussions narrowed the field to two choices—eagles or sheep. One of the gentlemen made a big deal about wanting the display to include Suffolk sheep with imposing horns. Ludtke was

quick to point out that Suffolk sheep did not have horns but that Rambouillet sheep, with magnificent, curving horns, might better fit the bill.

So Ludtke received his first commission for two charging Rambouillet rams cast in bronze. In order to have an exact likeness, David Drake, president of the Livestock Producers Auction Company, lent Ludtke a majestic Rambouillet ram as a model. The ram, which Ludtke and Erika named "Herman," actually lived in their backyard, and they became quite fond of their borrowed model. Ludtke had not attempted to do a sculpture of this magnitude before but was thrilled to be given the opportunity. He created the large armature in his garage and was able to sculpt an extremely accurate likeness of Herman by using the delicate touch of his fingers to form the fine details of its curly woolen hair. He commissioned the Modern Art Foundry in New York City to cast the sculpture. All that was left to do was make the mold and somehow transport it to New York City.

There was never a doubt in Ludtke's mind of following the "waste mold" process that the classical masters used to make a plaster cast of models, but it presented him with a serious challenge. The process involved covering the clay model, which had been sectioned off, with several inches of thick plaster. Once the plaster hardened, each section of the plaster mold had to be pulled away from the clay and cleaned, creating a perfect impression of the clay model. The sections of this hardened mold were then pieced together and liquid plaster poured inside. When the interior plaster hardens, it is in the shape of the original model. However, the exterior plaster mold must be "wasted" by carefully chipping it away, which is why it is referred to as a waste mold. Ludtke knew he would need help in creating his mold, so he asked a man named Jack Champion, owner of a local art and stone company, if he would be willing to assist. Champion and his wife, Melba, visited Ludtke and Erika to view the model and had some misgivings about this task. After some serious thought, he decided to help. When Ludtke asked Champion what made him decide to do it, he recalled Champion saying, "Well, I thought that anyone who was stupid enough to build a ram in his studio and doesn't know how to get it out, or doesn't know how to get it to New York, definitely needs some help!"

The two men set to work, applying the plaster to the clay model and making the seams where the mold would be separated. As Ludtke recalled, they

were "not very sophisticated, but the seams worked." These allowed for the ram's head to come off and for the men to make cuts down its back and along one leg to get the whole thing apart. The process was extremely arduous, with a lot of pulling and tugging, so in the afternoons Champion and Ludtke would take a break and engage in their common interest—playing a round of golf. Back in the garage, Champion instructed Ludtke on how to get the clay out of the external plaster cast. Once the clay was removed, he showed Ludtke how to apply soap inside the mold and grease it down, getting it ready for the pouring of the fresh plaster. They got the ram back together and mounted it on an A-frame assembly they had constructed. Once they had filled the external cast with plaster, they tried to move the ram into the next room but encountered a slight problem. The plaster cast got stuck in the doorway. After some tense moments, a few expletives, and a lot of struggling, they were able to get it through the doorway and onto a table, where it would be chipped out. From the beginning of this whole process, Champion had one condition—Ludtke would have to be the one to chip out the plaster, because he was certainly not going to do it. Ludtke agreed, although he had never chipped out a plaster waste mold in his life. He used a hand chisel, just as Rodin and other classical sculptors had used with their works. The process was long and tedious, with Ludtke having to be ever so careful around the ram's curlicues and its ears. When the beautiful white ram finally emerged from beneath the plaster cast, Ludtke was extremely proud. He then floated the plaster model of "Herman" in hundreds of pounds of packing popcorn and drove it to the foundry in New York, which then cast two bronze rams from his model. When they were dedicated in 1965, their placement not only marked the entrance into the Ethicon plant but also signified the start of a new chapter in the sculptor's life.[2]

Ludtke's next big break would come in the late 1970s in what began as a fortuitous relationship with none other than Texas billionaire H. Ross Perot. Back in his baseball days, Ludtke had developed a lasting friendship with a Boston Red Sox player named Pete Runnels. Runnels was also a close friend of Murphy Martin, a newscaster in Dallas. Martin was in turn a good friend of Perot, with whom he had done a number of interviews. One day, Perot mentioned a project he was pursuing—to have a statue created to honor his good friend and war hero, Brig. Gen. James Robinson "Robbie" Risner, a highly

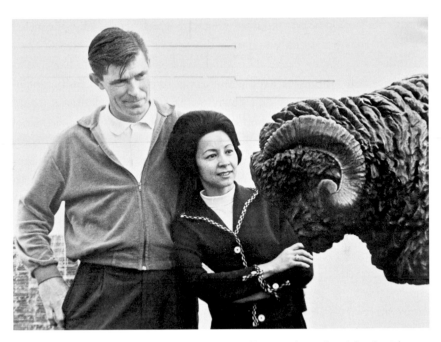

Ludtke and Erika admiring one of the Rambouillet rams he sculpted for the Ethicon commission in 1965. Courtesy of Erika Ludtke.

decorated air force pilot and former prisoner of war in Vietnam. Perot asked Martin if he knew of anyone who might be able to create the sculpture. Martin could not think of anyone but said he would ask around in Houston, and he talked to his old friend Pete Runnels. When Martin asked Runnels, the latter replied, "Yeah, I know of somebody who could do that and who would love to do it." He gave Ludtke's name to Martin, and the next thing Ludtke knew, Perot and Martin were at the sculptor's front door, wanting to see some examples of his work. Ludtke took them to see busts he had done of his friend Riley Leggett and Riley's son Paul. Not long after, Ludtke received a call from Perot, who described the project in further detail. Perot wanted to donate a four-foot statue that would represent the inaugural Risner Award, a trophy annually given at the United States Air Force Academy. The award would be given each year to the outstanding graduate of the USAF Weapons School and would serve as a tribute to Risner and all Vietnam-era prisoners of war. Perot asked

Ludtke if he would be interested in doing it, to which he replied, "Of course I would. I would give my right arm to do that for the Air Force Academy."[3]

Ludtke immediately began his research, reading about Risner's heroic feats in the air battles during the Korean War as well as in Vietnam. The biographical sources spoke clearly of the tremendous faith and courage Risner exhibited as a POW in the horrendous conditions of Hoa Lo Prison, the "Hanoi Hilton." He pored over Risner's autobiography, *The Passing of the Night: My Seven Years as a Prisoner of the North Vietnamese*, to get a better sense of Risner the man. Ludtke then invited Risner to his studio to be photographed wearing a flight suit and helmet. The sculptor and Risner immediately established a wonderful relationship, but Ludtke was a bit surprised by Risner's personality. He found himself wondering how anyone so "well-adjusted and so happy with himself and his life could possibly have gone through what he had and not be affected." Risner had endured severe torture and had spent more than three years in solitary confinement. Yet his faith, never-ending prayers, and optimism had given him the strength to persevere. Standing before this artist in his studio was a true patriot and hero. Ludtke, very patriotic himself, was elated to have the opportunity to sculpt Risner's likeness and spirit into clay.

When Ludtke informed Perot that he had nearly finished the clay model, Perot said he would send someone to the studio to review it. The next day, a few members of the Air Force Thunderbirds showed up at the Ludtke front door to take a look at the figure and check the accuracy, particularly with regard to the flight suit. They pointed out some minor things that needed to be adjusted but gave a thumbs-up to the clay model. Ludtke made the changes and finished the piece. He chose the world-renowned Roman Bronze Works foundry in New York to cast the statue, and Perot himself went to the foundry to see part of the process. Perot was completely satisfied and told Ludtke to go forward with the casting and to send the final bronze to the Air Force Academy. Ludtke asked Perot what he envisioned as the base for the sculpture at the academy, and Perot told him to design one. He asked Perot what he would like on it, and Perot replied, "Put something around the bottom of it. Planes are fine." So Ludtke made a model of the base, which would be in white granite. The side panels had bronze plates that depicted, in bas-relief, many of Risner's heroic feats in the air. Ludtke included airplanes swooping out

over a beach, representing every place that Risner had flown. Perot approved of the panels, and in 1976 the sculpture was unveiled at the Smithsonian Air and Space Museum in Washington, DC, where it was dedicated and the first Risner Award was presented in 1977. To this day, the award winner each year receives a bronze miniature replica of the Risner statue.[4] The Risner project was a watershed moment in Ludtke's sculpting career not only because of the opportunity he had been given to create a significant work of art for a prestigious national institution but also because it established a relationship with Perot, a man Ludtke would ultimately refer to as "the most influential person in my entire life."

In 1984, Ludtke received another major break in his sculpting career when Bill Lewis, a Washington, DC, businessman and art dealer, contacted him about creating a figure of President Ronald Reagan. His concept was to use the figure as part of a national Republican Party fundraiser. Lewis wanted the piece to depict the president in a casual manner and relate to his lifestyle on his California ranch.[5] Ludtke eagerly accepted the commission and researched the president's preferences, particularly when it came to horseback riding. Ludtke chose to portray the president sporting the more traditional riding clothes he preferred. The seventeen-inch bronze figure beautifully conveyed Reagan's vigor, energy, and ever-present optimism, depicting the fortieth president striding confidently forward, with his trademark smile. Lewis invited Ludtke and Erika to join him in presenting the number-one casting, entitled *The Spirit of Ronald Reagan,* to the president before a White House event in 1985. The opportunity to meet the president and to present him with a sculpture he created was a profound moment for Ludtke. Reagan was thoroughly impressed with the classical sculpture, and Ludtke recalled the president looking at the statue in amazement and then saying, "How did you do that? I had that riding outfit on the other day." Erika was starstruck when she met the president, recalling that when he entered the room, he immediately came to her first, took her hand, and said, "I'm Ronald Reagan." For the next three years, the figure remained on display in the Oval Office and now is a part of the Ronald Reagan Presidential Library collections.

Ludtke's next major commission also came from within the Washington Beltway. He received a very special telephone call one day as he was working

Ludtke, Erika, and President Ronald Reagan with the number-one casting of
The Spirit of Ronald Reagan bronze in 1985.
Courtesy of the Ludtke family.

in his studio. Erika came outside and shouted, "Larry, William Casey wants to talk to you." Ludtke replied, "William who?" Erika then said, "The William Casey with the CIA." He rushed to the telephone, and to his amazement, William Casey, director of the CIA, was indeed on the other end of the line. Casey wanted to have a bronze, life-size figure of Gen. William J. "Wild Bill" Donovan created for display at CIA headquarters. During World War II Donovan had been the first head of the Office of Strategic Services (OSS), which was the precursor of the CIA. He was considered to be the father of modern American intelligence gathering. Over the telephone, Casey shared how he had learned of Ludtke's name and reputation as a sculptor who had

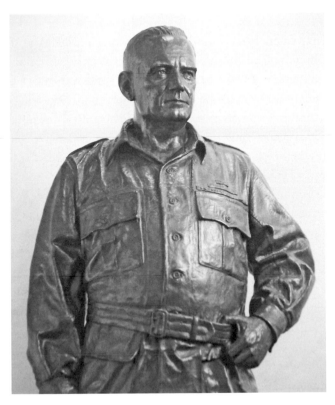

Sculpture of Gen. William J. "Wild Bill" Donovan, director of
the OSS in World War II and father of the modern CIA, which
is part of the OSS Memorial at CIA headquarters in Langley,
Virginia. Courtesy of Jaroslav Vodehnal.

extraordinary talent in doing portraits in the classical style. Arrangements were
made for Ludtke to go to CIA headquarters, where he met with Casey. There,
the two talked briefly about how Casey wanted Donovan depicted as he was
in a particular photograph that he had displayed. Ludtke was given the com-
mission, but unfortunately Casey suffered a severe stroke and was diagnosed
with brain cancer, which led to his death shortly thereafter, in 1987, amid the
Iran-Contra scandal. Casey's death briefly delayed the project, but the process
began moving again, and in 1988 the Donovan statue was formally dedicated,
with the Ludtkes attending the ceremony. The Donovan statue served as the

anchor piece for what would later become the OSS Memorial, dedicated in 1992, which is a monument consisting of a single star and an inscription on the south wall honoring those members of the intelligence organization who gave their lives in the service of their country during World War II.[6]

By 1988 sculpture had become Ludtke's primary profession, and he was juggling several projects in various stages. One opportunity came in the form of a most unusual client—SeaWorld. When SeaWorld decided to open a park in San Antonio in the early 1980s, the executives realized that placing the marine showplace in a landlocked major city located nearly two hundred miles from the nearest body of salt water presented unique challenges in terms of establishing a sense of identity. They considered Texans' unique sense of self and homeland and saw an opportunity to give the park a "local flavor and a taste of Texas" by tapping into the tradition of Texas heroes. With construction still in the planning stages, park officials designated an acre within the Cypress Gardens West section for the "Texas Walk," where life-size bronze sculptures of Texans prominent in business, the arts, education, agriculture, science, government, and the military would be displayed. The idea was to have Texas sculptors do the portraits. Elaine DagenBela, coordinator of the Texas Walk project, put together a team comprising the executives from SeaWorld and its parent company, Harcourt Brace Jovanovich, Inc., which personally reviewed more than one hundred portfolios submitted by sculptors.[7]

Ludtke remembered DagenBela calling in August 1985 to discuss the project and inquire about his willingness to submit a portfolio. His answering machine had picked up the message, so upon hearing it, he was anxious to return the call. Erika, ever the voice of reason, cautioned him not to get his hopes up, as they had been disappointed before. Ludtke returned the call, "with trepidation that had been bred from so many such calls that had just faded away when followed up." DagenBela summarized the project again, told him she had received his name from the National Sculpture Society, and offered the names of some of the other sculptors they were considering, including Glenna Goodacre, Jim Reno, and Juan Dell, three widely recognized sculptors, with whom Ludtke was familiar. He asked if she would be willing to read the names of the men and women who were to be honored with statues. At the top of the list was Gen. Sam Houston. For Ludtke, "It would be

beyond my greatest expectation to ever have a request to do a figure of the most famous Texan of them all, Sam Houston. As DagenBela read the remaining names, it was all I could do to contain myself from saying, 'Let me do them all.'" Ludtke told her that the opportunity to do the figure of General Houston should be the ultimate dream of any man who called himself a Texan and a sculptor. But he also added that they "could give all the other figures to anyone they chose" if they would just let him do the figures of Houston, William Barret Travis, Babe Didrikson Zaharias, Lyndon B. Johnson, Dwight D. Eisenhower, and David "Davy" Crockett. DagenBela laughed and told him that Crockett was not on the list given to her. Ludtke wanted her to know even at this early stage that he felt strongly about Texas and that the Texans he mentioned were special to him in more than a casual way. As he stated, "My concern about proper sculptural representation of these heroes was of primary importance. I had studied over the years the efforts by other sculptors to capture in bronze and marble some of these folks. I knew what was out there, and I wanted to contribute to Texas history with the images I might create as well as to test my talent in comparison."

Ludtke received another call from DagenBela with the good news that he was one of six sculptors chosen for the unprecedented commission. Leo Zuniga, SeaWorld's vice president for public affairs, claimed his favorite memory of the three years spent getting the park ready "was the day a group of us met first with Larry Ludtke in his Houston studio, then flew by private jet to Laredo to see Armando Hinojosa and finally to Santa Fe to visit with Glenna Goodacre. I was on an artistic 'high' like I can't describe by the time we got back to San Antonio."[8] Ludtke was awarded the opportunity to sculpt six figures: Sam Houston, Babe Didrikson Zaharias, Lyndon B. Johnson, Howard R. Hughes Sr., Henry B. Gonzales, and Edward H. White II, one of three astronauts killed in the Apollo I fire in 1967. Ludtke could not have asked for more and was absolutely thrilled to have this once-in-a-lifetime opportunity. He felt that this commission was one of the greatest things, personally and professionally, to ever happen to him. He recognized that not only would this commission open doors for him careerwise but also, equally important, his own sense of patriotism and pride in being a Texan would flow through his hands and onto the clay, breathing a soul and essence into each of these heroes.

Even before Ludtke got the final approval to do the SeaWorld bronzes, he called his friend, Philip Schiavo at Roman Bronze Works in Corona, New York, to check pricing and schedules for casting whatever pieces he was awarded. This foundry had a glorious history of providing many of the nation's patriotic monuments, statues, fountains, ornate public doors, and other sculptures. For nearly a century, it was a central player in America's sculptural tradition. Riccardo Bertelli, a Genoan with a background in science, art, and chemical engineering, visited the United States in 1895, and, in talking to artists and sculptors, he recognized the country's need for a foundry that could cast sculpture in the historic lost-wax process. Together with Giuseppe Moretti, he founded the Roman Bronze Works foundry in 1897 in Manhattan, utilizing artisans they brought from Italy who could transfer the Old World techniques from Europe to North America. Frederic Remington, Augustus Saint-Gaudens, Daniel Chester French, Henry Merwin Shrady, and many other well-known sculptors all used Roman Bronze. When Ludtke developed a working relationship with Roman Bronze, Philip Schiavo was the current owner, having taken over the foundry from his uncle. Schiavo was a very "hands-on" owner, often pouring molten metal himself. Ludtke admired his business practices and the extraordinary quality of the foundry's work, and he appreciated the extensive collaboration that the foundry always encouraged between its staff and the sculptor.[9]

Ludtke got started first on the seven-foot Sam Houston statue, deciding that he would depict Houston in a glorious manner befitting the Texas hero and statesman. As a native Texan, he remembered from childhood seeing textbooks with etchings and paintings depicting Houston wounded, sitting under a tree after the Battle of San Jacinto, or "dressed like a pauper, with other renderings showing him as a doddering old man with a cane and shawl wrapped around his shoulders." Ludtke did extensive research and knew that none of those images accurately reflected the flamboyant style of dress of which Houston was fond as president of the Republic of Texas, particularly his affinity for capes, which he donned for special occasions. In the SeaWorld figure, Ludtke chose to depict Houston in grandiose style. He went to a local costume store and acquired all of the items he wanted his figure of Houston to have: high riding boots, vest, a cane, and a full-length cape. He employed a

model to wear the costume and then took photographs from every possible angle. As he set about creating the armature, the cape presented quite a challenge. Ludtke built the figure first and then used steel reinforcing rods for the cape, which he bent and put into the armature's structure. As he did with all portrait figures, Ludtke first crafted the clay figure in the nude to make sure that he had all the anatomy and physical features to scale. Using many batting squares (a quilting fabric used as insulation between a top layer of patchwork and a bottom layer of backing material), he laid the pieces on top of the nude figure and applied shellac on top of them so that they would remain in place on the clay. Once that was done, he then used pieces of clay to mold the clothing on top of the figure. As Ludtke pointed out, "I can put a fold in place, for instance, when crafting the pants, and it keeps me from modeling beneath the surface. That is why it always looks like there's a human being underneath the clothes." He learned this very laborious technique from Waldine Tauch, and he believed that it was an essential element in creating great portrait sculpture. Ludtke would not do it any other way. To him, "it's the authenticity—it's the line of history of how to do sculpture properly, following the techniques that have been followed forever."

Ludtke followed the same procedure with the remaining five figures for which he was commissioned, each one unique in its own right and requiring individual research as he took painstaking efforts to bring their stories to life through the clay. He hired his master moldmaker, Cesare Contini, from Greenwich Village in New York, to come to Texas and create molds of all six figures. Contini, a fifth-generation artisan, learned the craft of creating plaster molds from watching his father, Attilio, who brought his craft to the United States in the 1890s. Together, they operated A. Contini and Son, making plaster molds for an impressive array of famous sculptures, including Remington's *Bronco Buster,* James Earle Fraser's equestrian *Theodore Roosevelt* in New York City, Rudulph Evans's *Thomas Jefferson* for the center of the Jefferson Memorial, Henry Merwin Shrady's massive General Grant on horseback for the Ulysses S. Grant Memorial in front of the US Capitol, several state monuments at Gettysburg, and numerous other famous pieces. Coincidentally, Pompeo Coppini worked with Attilio Contini, contracting him to provide plaster

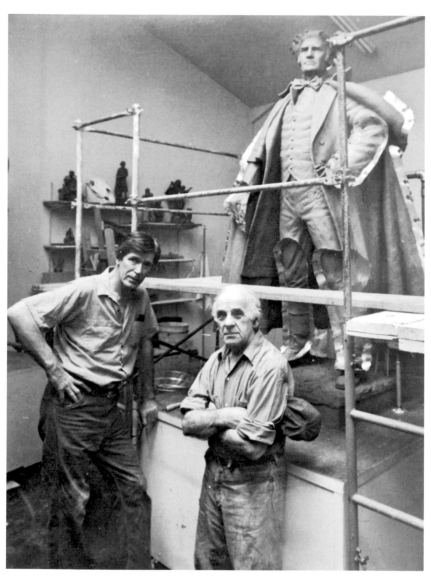

Ludtke and his longtime moldmaker, Cesare Contini, in front of the
Sam Houston sculpture commissioned in 1988 by SeaWorld.
Courtesy of the Ludtke family.

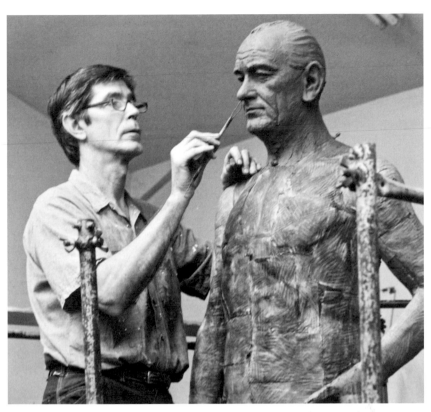

Ludtke working on the clay model of the Lyndon B. Johnson sculpture, commissioned by SeaWorld. Courtesy of the Ludtke family.

casting in 1935. The tradition of a Contini making molds of sculpture created in Coppini's plastilina clay continued with Ludtke and Cesare a decade later.[10]

Contini always welcomed the opportunity to travel to Texas and work with the sculptor, with Ludtke acknowledging that Contini "took a liking to him." The true charm of Contini came through during the arduous tasks of creating the molds and determining precisely where the molds were going to come apart as he regaled Ludtke with wild tales about his experiences with other artists. By watching Contini make molds and practicing the Old World techniques, Ludtke learned a great deal about the moldmaking process. He was

able to apply this firsthand knowledge to his own sculpting practices. The wisdom he acquired from his work with Contini helped Ludtke understand the moldmaker's vital importance to the overall finished product. To make an inaccurate mold meant the original sculpture could be ruined and the artist's vision forever altered. Working with Contini gave Ludtke high expectations of quality work, and he carried these invaluable lessons with him throughout his dealings with the sculpting community for the rest of his career.

The casting at Roman Bronze took nearly a year to complete. Ludtke visited often, checking on the progress. He always experienced apprehension when turning over his pieces for casting—would they turn out as he intended, with no mistakes, and would the foundry complete the work by his deadline? With the SeaWorld commissions, he had six statues being cast at the same time, and the pressure was intense. In December 1987, he spent fourteen days at the foundry overseeing the work being done on his pieces. Ludtke stayed in a little apartment above the bronze works, taking in all the sounds and smells that come from a foundry. Its environment is made up of the heat generated by industrial furnaces, filth from the pounds of dust and dirt, the loud clatter of tools and shouting voices, and a smell that Ludtke says is very distinct, unlike any other. As he once reflected, "The roar of the foundry is punctuated by a smell made up of a combination of wax, plaster, metal, shellac—giving off an odor that either one loves or hates. To me, I just love it because it is a fascinating smell." While there, the sculptor learned all he could about the foundry, actually doing work himself, such as the chasing of pieces, knocking out plaster castings, and cutting gates and pins. He wrote in one of the many journal entries that he made at the time, "Marvin [a foundry craftsman] and I are working on the bust of Houston—using power tools and wearing a mask, but still the bronze burrs burn my arms and hands." His experience at Roman Bronze made a deep impression on him—the people, their labor, and the unique work environment of a century-old foundry. All of this came together to provide him invaluable insight and knowledge of what it took to capture, in bronze, the very souls he first created in clay.

When Ludtke's statues joined the other twelve on the Texas Walk at SeaWorld San Antonio, it was a proud moment for him and Erika. He was the only sculptor who had that many sculptures as part of the project. Six Ludtke

pieces stood among the wildflowers and live oaks of the beautifully landscaped walk, each looking as if it could suddenly hit stride and walk among the visitors passing by. The authenticity in their physical features was particularly striking, but perhaps even more amazing was that Ludtke succeeded in bringing the character and grit of these Texas heroes to life for the thousands who stopped and admired them.

Return to Aggieland

ALTHOUGH LUDTKE HAD attended Texas A&M for just two years before withdrawing to play baseball, he always had an affinity for the school, particularly given its long-standing traditions and values. Patriotism, honor, and loyalty have remained synonymous with the A&M culture since the school's founding in 1876, and Ludtke upheld these values as the standard for himself to follow. It is not too surprising, therefore, that the university and Ludtke would cross paths again, and this time the campus became home to several of his works. In the late 1980s, Professor Dan Fallon, dean of the College of Liberal Arts, reached out to Ludtke after discovering the university's link with Pompeo Coppini, who in 1915 had created one of the few sculptures of any significance on campus at the time—the bronze statue of Gen. Lawrence Sullivan Ross, president of Texas A&M from 1891 to 1898. Fallon was concerned about an A&M tradition whereby the freshmen, or "fish," in the university's Corps of Cadets applied brass cleaner to the statue. Unfortunately, decades of polishing with Brasso® had eroded the patina and even altered the original details of the piece. Fallon called the director of Texas A&M's Memorial Student Center, James R. "Jim" Reynolds, to see if he shared his concerns and to also let him know that he had identified an artist (Ludtke) in Houston who in fact had been a student of Coppini's foster daughter, Waldine Tauch.[1] The two men decided to contact Ludtke about ways to protect and restore the statue, and Reynolds also wanted to invite him to campus to present a program to students about Coppini and the history of the sculpture. Ludtke was thrilled to do so and sub-

sequently visited the A&M campus on many occasions to meet with students and discuss the Coppini piece as well as his own work. Erika frequently accompanied him on these visits, and the Ludtkes loved being with the Aggie students and becoming acquainted with Jim and his wife, Pam. Reynolds would visit the Ludtkes every time he was in Houston, and the two couples developed a warm friendship that would last for more than twenty years.

Having recognized Ludtke's fondness for A&M students and passion for his art, Reynolds invited him and Erika to participate yearly in a program sponsored by the Memorial Student Center (MSC) called the MSC Spring Leadership Trip. This program took selected Aggie seniors to Houston for a long weekend, exposing them to art and culture by having them visit museums, attend symphonies and plays, and dine at fine restaurants. Reynolds thought it would be a great idea to bring students to meet a real sculptor, to visit him in his studio, and to learn about the sculpting process and his life. The Ludtkes agreed to participate, and each spring for many years a big maroon bus would pull up in front of the house, and fifty Aggie students would descend upon the Ludtke home and studio. The artist would divide the students into small groups, talking to one group in his studio at a time, while Erika entertained the others around the pool and inside the house.

One evening in 1991, a special idea was born during a dinner party at the Ludtkes' home. The Reynoldses and their friends, Dick Conolly and his wife, were the guests. Conolly, a former A&M student from the class of 1937, was a longtime supporter of the visual arts at the university and had been a close friend of Gen. James Earl Rudder, the D-Day hero who had been president of A&M. After dinner, Conolly commented on the small bronze statue of Ronald Reagan sitting on a side table and inquired about it. Ludtke told the story of how the sculpture came about and said, "You might be interested to know that the Reagan piece is made with the same clay that Coppini used to model the Sul Ross statue on campus." Reynolds and Conolly turned to each other, and Reynolds remembered that "both of us simultaneously thought, by God, we've got to get a statue of Earl Rudder made out of that same clay." As Conolly likewise noted, "With the Coppini clay being handed down to an artist with ties to A&M, this was something that you simply could not ignore. It was a true A&M moment wrapped in legacy and tradition."[2]

Conolly and Reynolds went back to A&M to get the administration to buy into the idea, with Conolly leading the effort to raise funds for the sculpture. Frank Muller, class of 1965, was also asked to help coordinate fundraising. Muller had been the student body president during a tumultuous period, when Rudder faced the challenge of transforming the college from an all-male military school focused on agriculture and engineering to a coeducational university, with participation in the Corps of Cadets becoming optional. These hard decisions were vehemently opposed by many former students, but the changes were necessary in order for the institution to survive and flourish. Hundreds of thousands of students got to become Aggies and experience Texas A&M due to Rudder's vision and courage, and now many of these former students wanted to contribute to something created in his honor. "The clay story always would get to them, too," Reynolds recalled.[3]

To say that Ludtke was pleased to be a part of this project would be a huge understatement. He was thrilled to have the honor of one of his pieces being placed on the A&M campus, where it would stand forever. He also recognized the responsibility with which he had been entrusted, writing in his proposal, "I will do my utmost to create a work that will stand the test of time, just as Coppini's figure of Lawrence Sullivan Ross has done."[4] Ludtke never met Rudder, but he crafted his likeness by talking with his widow, Margaret Rudder, as well as many of his friends, and by poring over numerous photographs and biographical records. It was through this research that the sculptor was able to capture the essence of the man. Ludtke often said, "That is what's so fun, delving into the character of a person. You have to have the soul of the person to get it right." Get it right, he did, as evidenced when Margaret Rudder came to his studio with Reynolds and Muller to view the completed, full-size clay model. She nearly fainted when she looked up at her beloved husband, marveling at how lifelike the model appeared. Frank Muller overheard her saying, "I think I'm falling in love all over again." Muller concurred that Ludtke had indeed nailed it, noting, "Larry is truly an artist who worries about details, a first-class professional who gets up in the middle of the night because he realizes the eyebrows aren't right."[5] At a rain-soaked dedication ceremony in October 1994, Ludtke spoke of the great honor he had felt in creating the sculpture for a "great university that does not forget its heroes."

One of seven bas-reliefs of the Aggie World War II Medal of
Honor recipients, commissioned by Texas A&M University.
Courtesy of Jaroslav Vodehnal.

Ludtke's body of work on the A&M campus expanded as university officials
recognized his talent and reputation and admired the authenticity and beauty
of his work. While working on the Rudder statue, he was commissioned to do
several additional projects. For the opening of the Sam Houston Sanders Corps
of Cadets Center, Ludtke was asked to create bas-relief wall sculptures of the
seven Medal of Honor recipients from the university. Texas A&M, Virginia
Tech, the University of Washington, and Harvard have the highest number
of honorees outside the service academies. The A&M recipients were hon-
ored with plaques in the Memorial Student Center, with each one displaying

a portrait, a specimen medal (not the actual medal), and a written account of the recipient's heroic actions during World War II. With the new Corps Center opening, the university wanted to honor and remember the seven Aggie medalists, five of whom made the ultimate sacrifice, in a more permanent way. Ludtke said it was a "very emotional experience for me to see these men come to life in my studio." In addition to using numerous photographs as sources, he had live models dress in authentic uniforms and brass of the period to capture the likeness of each honoree during the sculpting process. Brad Neighbor, one of Ludtke's moldmakers, noted, "Larry's work in the round was awesome. I think a true test of an artist's ability is in the form of a bas-relief. It's not as easy as it looks. Somehow he would get them to 'pop' and gave them life, as if the person was truly emerging from the relief."[6]

Ludtke was also commissioned to create a bust of J. Wayne Stark for the Memorial Student Center Opera and Performing Arts Society (OPAS) at A&M. Stark, the founding director of the Memorial Student Center, saw a need for Aggie students and the surrounding Bryan–College Station community to gain exposure to the performing arts. He enlisted members of the community to help him create OPAS in 1972, and, as a result, hundreds of ballet performances, Broadway shows, symphonies, and operas have been brought to the A&M campus and presented in Rudder Auditorium, where the bust is displayed. On many occasions, the Ludtkes were guests of their dear friends, the Reynoldses, for these OPAS performances and got to experience firsthand Stark's vision in action.

In 1993, Ludtke's relationship with Texas A&M led to a once-in-a-lifetime opportunity to make a special presentation to the Right Honorable Lady Margaret Thatcher, the former British prime minister. He had been commissioned in the early 1990s to do a maquette or working model–size bust of Winston Churchill for the International Churchill Society. The society's president, Richard Hazlett, became aware that the Wiley Lecture Series committee of the Memorial Student Center at Texas A&M had succeeded in booking Thatcher to do a public lecture on the campus. He saw the announcement in a Dallas newspaper and, knowing of Ludtke's relationship with the university, called to ask if there might be an opportunity to present a Churchill bust to the former prime minister at that event. After working out the logistics,

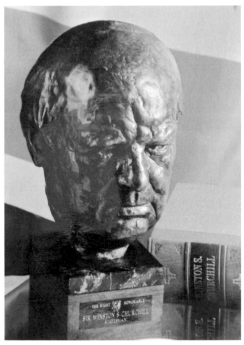

The Winston Churchill bust commissioned by the Churchill International Society. Ludtke and Dallas businessman Richard Hazlett, president of the society, presented the Churchill bust to former British prime minister Margaret Thatcher at Texas A&M University in 1993. Courtesy Ludtke family.

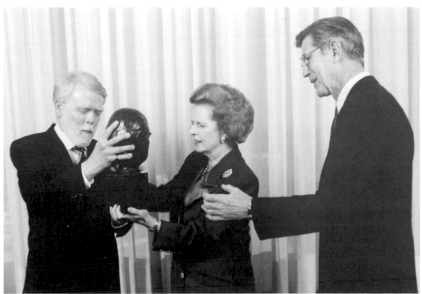

Ludtke, his wife, and Hazlett were invited to meet Thatcher as they passed through her receiving line and to present the bust to her. Upon receiving the bust, Thatcher remarked that Churchill was her greatest hero and then commented that she would place the piece on the fireplace mantel in her home. Although she was unable to carry the heavy bust back to London in her luggage at that time, the bust was hand delivered to her home at a later date by some A&M Wiley Lecture Series students studying in England. Thatcher was so appreciative, she invited them to stay for tea and recalled meeting Ludtke, commenting, "He truly represented my image of the tall Texan."[7]

During this same period, Ludtke's friend and fellow renowned sculptor, Veryl Goodnight, had been approached to create a piece that would be donated to A&M's College of Architecture. Joe Hiram Moore, class of 1938, and his wife, Betty, wished to commission a sculpture of their deceased son, Stephen, a 1973 graduate in environmental design. They wanted to have their son's likeness accompanied by the figure of a golden retriever since their son always seemed to have one or both of his dogs by his side. Knowing that "male figures were not my strong suit," Goodnight wanted the best for the Moores and knew that Ludtke would do an outstanding job.[8] She asked him if he would be willing to collaborate with her—he would do Stephen's portrait and she would do the dog. The piece, entitled *ARCH 406*, refers to a senior design course and sits behind the Langford Architecture Center on campus. After studying photographs of Stephen, Ludtke depicted him as if he were walking to or from class, with his backpack slung over one shoulder. He is beckoning his constant companion, the golden retriever, to follow. The two sculptors were able to create two pieces that together exude a tremendous amount of liveliness and energy, as well as reveal the extraordinary bond between a young man and his dog.

As Ludtke once remarked how Texas A&M was not one to forget its heroes, it was very appropriate that his final piece for the university was that of the most decorated general officer in its history. In the late 1990s, Ludtke received a commission to create a likeness of Lt. Gen. James F. Hollingsworth, class of 1940, to be placed at the heart of the Corps of Cadets dormitory quadrangle. Hollingsworth, a hero of World War II, Korea, and Vietnam, stands as an ever-present reminder to Aggie cadets to lead with honor, valor, and ser-

Bronze sculpture of Gen. James Hollingsworth, *Danger 79er,* located on the Corps Quadrangle at Texas A&M University. Courtesy of Jaroslav Vodehnal.

vice to country. The seven-hundred-pound sculpture is entitled *Danger 79er,* after Hollingsworth's radio call sign during his tours of duty in Vietnam. On the day of its unveiling, Ludtke brought a smile to the old general's face in the front row of spectators when he shared a secret at the end of his speech. Looking at Hollingsworth, he revealed, "General, in bronze, you are now officially three inches taller than your old friend, General George Patton, whose bronze statue stands at West Point."[9]

Again, all of Ludtke's pieces on the A&M campus have in common the Coppini clay. All thus remain forever linked to A&M's oldest sculpture, that of Lawrence Sullivan Ross, the original statue for which Coppini used his special plastilina clay. When Ludtke worked with this clay, he was touching a legacy of art and classical craftsmanship, as well as a true part of Texas history.

Brothers Again

As THE SUN CAME UP over Little Round Top at Gettysburg, Ludtke and his good friend Jim Reynolds drank coffee and thought about how they were viewing the same sunrise the Confederate cavalry must have seen as they were riding up the slopes of Devil's Den in July 1863. On this mostly clear morning, with only a little fog on the ground, the two men wondered what it must have been like on that very spot 130 years ago, when fifty thousand men lost their lives in three days on this battlefield. Ludtke not only thought about the battle and its historical significance but also reflected on the circumstances that had brought him to this very place—sitting on a hill at Gettysburg, watching the sun come up and knowing that one of his sculptures would stand forever on this hallowed ground.

One morning in his studio in Houston, Ludtke had received a call from a man in Baltimore, Maryland, informing him that a competition was going to be held to create a sculpture for the Gettysburg battlefield that would be a memorial to Maryland soldiers. Citizens for a Maryland Monument at Gettysburg was a group of prominent Marylanders, including even the governor himself, William D. Schaefer, who recognized that their state did not have an official memorial at Gettysburg.[1] This representative informed Ludtke that the group had narrowed its search to four sculptors and wondered if he would like to be considered as an alternate candidate. The group had seen his work and received his name from the National Sculpture Society. Ludtke never hesitated. He said, "You bet your life. I would do anything to have the opportunity

to do a piece of work on America's most hallowed battlefield, Gettysburg." However, Ludtke did not hear anything about the project for a while, but he held out hope, as he had many times before with other commissions. Erika cautioned him not to get his hopes up, but "if it had been a chance that was a thousand to one, I don't care—I would have taken it," he said.

A few months later, a gentleman called to say that one of the finalists under consideration had dropped out, and he wondered if Ludtke would create a model and send it up to the judging panel. He immediately said he would, then dropped everything and began work on a clay model. Unbeknown to Erika, he already had been reading everything he could about Maryland and its involvement in the Civil War. He researched its history as a border state and learned that boys from Maryland fought on both sides in the war. Per the committee's instruction, the sculpture was to consist of two figures. Ludtke decided to create an emotional piece that consisted of two men, one Union soldier and one Confederate soldier, both "emerging from the chaos of the rubble strewn battlefield in a search for shelter from the turmoil around them," as he wrote in his proposal to the committee. The Confederate soldier holds his torn left leg in a tight grip, "grimacing in pain, looking out for respite." The Union soldier, although his right arm appears to be bandaged and useless, is helping support the wounded Confederate soldier by gripping his belt with his left hand. The Confederate soldier has his hand gently placed on his enemy's back. Neither is shown with their weapons in hand nor being dominant over the other. They are on the same plane and symbolically placed shoulder to shoulder, both looking out, away from the battlefield. Both have a lost look on their faces, as if to ask, "Where do we go from here?" For Ludtke, that summed up the major point of Gettysburg, as this battle became the turning point for the war and preservation of the nation. To show enemies arm in arm trying to get out of this battle carried a much deeper meaning.[2]

Ludtke took the clay model to Maryland, and the judges for the competition, which included the dean of Maryland sculptors, Reuben Kramer, as well as two other sculptors, all chose Larry. He was officially awarded the commission in March 1993. O. James "Jim" Lighthizer, president of the Civil War Preservation Trust in Washington, DC, and Maryland's secretary of transportation at the time, was very impressed with the sculptor's dramatic representation of the

theme of reconciliation and the fact that the piece did not depict combat. "It is the only sculpture I know of to be at Gettysburg where the soldiers are not preparing to be in combat, but rather helping one another," he said.[3]

Ludtke could not wait to get started on the piece. He worked with a large number of Civil War reenactors who provided photos of themselves modeling the correct uniforms. He also acquired some of the actual wartime paraphernalia, such as canteens, haversacks, and cartridge boxes so that he could get every detail perfect. His dear friend Jaroslav "Jari" Vodehnal served as a live model for the Confederate soldier, and it is his face one sees on the finished bronze. Vodehnal had met Ludtke in 1992, after his sister had been a model for one of the sculptor's other pieces. Ludtke followed the philosophy of Coppini, who believed that if a portrait "was to be alive, the model should not be made to pose like a dummy nor made to keep still, but he should be used when full of life and character."[4] When Ludtke found that Vodehnal was a runner with no body fat and well-defined muscles, he knew the man would make the perfect model for pieces on the cusp of action, with all the muscles taut. Vodehnal, in turn, was fascinated by Ludtke's work, remembering that when he first saw one of the artist's pieces, he felt as if he could "go up to it with a stethoscope and feel the heartbeat."[5]

For the Maryland state memorial, Ludtke would start his day in the studio by turning on the soundtrack from the 1993 movie *Gettysburg,* which he played over and over again. It provided him with tremendous inspiration and "hit just the right mood." He was able to create the eight-foot piece fairly quickly, and he had the bronze cast at Shidoni Foundry in Tesuque, New Mexico, located just outside Santa Fe. Ludtke had used several foundries after Roman Bronze shut down, but when he discovered Shidoni, he found it better able to serve his needs, personality, character, and business practices. Furthermore, he believed the quality of their work to be impeccable. It was at this foundry that Ludtke found a "home away from home." To Ede Ericson Cardell, the foundry manager at Shidoni, it was very apparent that everyone in the foundry respected the sculptor and looked forward to his visits. "The workers always wanted to 'get it right' for Larry," said Cardell and her husband and associate Mike Cardell, "because they so admired his attention to detail and his professionalism. Larry was never rude or arrogant—he just wanted it done

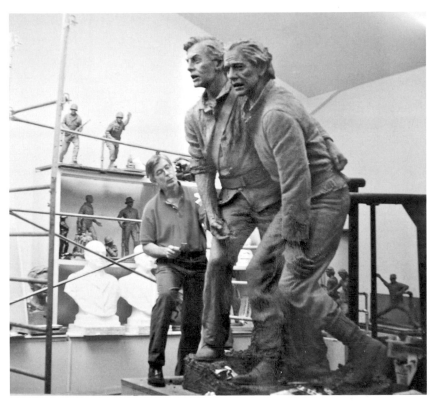

Ludtke in his studio working on *Brothers Again,* the Maryland state memorial sculpture for the Gettysburg battlefield. Courtesy of the Ludtke family.

right."[6] Ludtke spent a few weeks there, supervising the staff's efforts in the final stages as they prepared the piece. As Ludtke pointed out, "Shidoni has always been great. They've worked with me in every way. I'm constantly checking and making certain that I have the bronze come out as I wish it to be."

The sculpture, titled *Brothers Again,* was transported to Gettysburg, placed at a site that overlooked Culp's Hill, where most of the Marylanders fought one another, and prepared for the dedication ceremony. The day before the ceremony, Lighthizer gave Ludtke, Erika, their daughter, Ellen, and the Reynoldses an amazingly detailed tour of Gettysburg, and they also spent time visiting the Union and Confederate encampments set up by reenactors. As

Ludtke making his remarks at the dedication ceremony for *Brothers Again,* the Maryland state memorial at Gettysburg, in 1994. Courtesy of the Ludtke family.

Reynolds remembers, "To stand there by the fires with porcelain pots and cups of coffee, talking to 'General Longstreet' and 'General Meade,' was an incredible experience."[7] That night, Reynolds and Ludtke stayed up watching the movie *Gettysburg,* which had recently come out on video. The following day, on November 13, 1994, the Maryland memorial was dedicated in a ceremony attended by a crowd of more than six thousand, comprising Civil War reenactors, governors and dignitaries from both Maryland and Pennsylvania, guests such as Ludtke's family, and his good friend, renowned sculptor Veryl Goodnight and her husband, along with hundreds of battlefield visitors. When Ludtke looked out from the podium at the large crowd, Lighthizer remembered him commenting, "Where were all these folks when I was pitching?" Maryland governor William Schaefer praised the memorial's depiction of two enemy soldiers helping each other off the battlefield as "brotherhood personified." He remarked, "Maryland was to pay a frightening price for the geographical accident that placed it between the Union and Confederate states.... Our great state tore itself apart and it took time to heal the wounds. Larry's hands captured the essence of that healing with this dramatic piece."[8]

Tee Times and Brushstrokes

WITH THE OPPORTUNITY to create the likenesses of presidents, military heroes, sports legends, and historical figures comes a tremendous amount of responsibility and a significant amount of self-imposed pressure to "get it right." When Ludtke was sculpting and had trouble making something look exactly as he thought it should, his response was to walk away from it for a while. He often took such a walk on the golf course, where he felt pure joy. With a six handicap, he definitely knew his way around the game of golf, but being the best was not what golf was all about to Larry. Being in the presence of nature and among friends, Ludtke enjoyed golf because it provided the opportunity for relaxation, competitiveness, and a way to constantly reaffirm his own moral compass. He liked to say that "life is like golf—you're either in bounds or out of bounds."

Waldine Tauch had cautioned Ludtke that if he wanted to become a master sculptor, he would need to "stay off the golf course, because there's no time left to play golf." In her world, sculpture took up 100 percent of her time and encompassed every part of her life. Yet Ludtke sought a different approach and used golf as a way to refocus his mind when sculpting masterful creations. Tauch may even have been proud to learn that his firsthand knowledge of golf came in handy when given the opportunity to create likenesses of two great golf legends—Babe Didrikson Zaharias, whose image was part of the SeaWorld commission, and Byron Nelson, whose likeness Ludtke sculpted for placement at the Augusta Golf and Gardens in Georgia. Ludtke could not

follow her advice; the game gave him a respite from work and he could never give it up. He often said "there is nothing any more enjoyable than playing golf with your friends," and he loved to do so with friends like Adrian McAnneny, Bill Guthrie, Bob Eveslage, and Earl Scott. These men got to see the competitive side of Ludtke; he always wanted to shoot the best game he could but was never an "in-your-face" competitor. Adrian McAnneny played golf with the sculptor two or three times a week, usually meeting after work and typically playing only nine holes at what was then the Texaco Country Club. As McAnneny remembered, "Larry and I played at the end of the day, and we usually got to watch the setting sun provide a colorful backdrop, which silhouetted and blackened the trees on the course. Towards the end of each round, we would sit in the cart for a few minutes to enjoy the scenes Nature had painted for us and the peace surrounding us." Ludtke was the perfect gentleman on the course, followed protocol, and was the ideal golf partner. McAnneny noted that it was a pleasure to see a person play the game the way it was meant to be played. He also pointed out that every aspect of human emotion is elicited in a round of golf—fear, anxiety, appreciation, love, confusion, confidence, and how one manages disappointment. "You can tell a lot about a person when playing golf with them. With Larry, you could immediately sense his mental keenness and sharpness. Watching how he handled his emotions on the golf course provided insight into how he managed his emotions in life, and Larry managed things very even-keeled, and took things as they came."[1] Ludtke had his own take on golf as it related to everyday life: "Golf is the greatest challenge of all. You can't beat the game. You beat it today, it'll whip up on you tomorrow, just like life can sometimes do."

Ludtke introduced his friend and occasional model, Jari Vodehnal, to the game, and Vodehnal often joined Ludtke and McAnneny for some enjoyable rounds. When he joined the group, their rounds of golf gained a whole new dynamic because he was much more emotional than either Ludtke or McAnneny. Vodehnal sensed that the sculptor left things behind on the golf course—"it was almost like meditation to him." Sometimes this "Triumvirate at Texaco" would become the "Fierce Foursome" when Ludtke's son, Erik, came to town and joined the game. Ludtke took great pride in all of Erik's achievements, but the love these two shared for golf was a special connection

Ludtke taking a swing on the golf course while his son, Erik, watches from the golf cart. Golf was Ludtke's favorite pastime and a respite from his sculpture work. Courtesy of the Ludtke family.

between father and son. Erik learned the skills of the game from Ludtke, especially the most fundamental act of holding his golf club. Watching his father, Erik commented that Ludtke, even though he had large hands, "held a golf club with very soft hands, the way you are supposed to." The sculptor had a soft touch around the greens and a natural rhythm on the course, which ironically mirrored his sculpting techniques in his studio. "Dad's pure instincts when playing golf were amazing," Erik stated, "and with some instruction, there is no telling what might have happened or how far he could have gone with the game." When Erik joined the golfing group, McAnneny and Vodehnal could tell that the apple had not fallen far from the tree. Erik was a skilled golfer as well, but, more importantly, the influence of Ludtke's love, character, and values was clearly evident to those who had the pleasure of being with both father and son.[2]

Ludtke's family was of the highest priority to him. The love and partnership that existed between him and Erika was the foundation on which everything

else was built. Ede Ericson Cardell at Shidoni Foundry remembers that on every occasion when Ludtke either visited the foundry or talked with her over the telephone, it always came through loud and clear that Erika was the center of his world and that he absolutely adored her. What had begun as a three-month courtship became a forty-eight-year romance. When asked the key to such a successful marriage, Ludtke explained that the cardinal rule for both him and Erika was that they never turned out the light at night when mad at one another. Each day of their marriage would begin and end on a positive note. In some ways, Ludtke's relationship with Erika runs much deeper when taken in the context of the "light going on for him" when he was on their European honeymoon and became captivated by sculpture. His romance with art originated from his romance with her. Throughout their years together, her love and support gave him the amazing freedom to follow his heart's desire, ultimately making his art possible. The Ludtke children—Erik and Ellen, along with Kim, Larry and Erika's adopted daughter—witnessed firsthand their beautiful love affair and always knew how much their parents loved one another and them.

While golf and time spent with his family provided Ludtke with a respite from sculpting, another art form emerged as a release for him: painting. When he was working on so many sculpture commissions and could not find the time to get away to his place of solitude on the golf course, Ludtke found himself needing another outlet from the strain of sculpting. As he put it, "Golf is an outlet for me, but many times I felt I could not afford to leave the sculpture for an extended period of time. I needed another creative outlet that kept me in the studio but took my mind completely off sculpture. Painting served that purpose for me." Ludtke would immerse himself in his paintings, depicting scenes that had significant meaning to him, such as Civil War sites, golf courses, the Texas Hill Country, or other landscapes that he considered beautiful. His painting *Burnside's Bridge* depicts the landscape and the famous bridge in Sharpsburg, Maryland, that is part of the Antietam National Battlefield. At this spot, it took Gen. Ambrose Burnside and twelve thousand Union soldiers under his command more than half a day to make their way across the bridge. Confederate sharpshooters were hiding behind trees and boulders on the hillside and driving back the Union troops. The Union soldiers finally made it

Ludtke's painting *Burnside's Bridge* depicts the famous span at the Antietam National Battlefield in Sharpsburg, Maryland. Courtesy of Jaroslav Vodehnal.

across but not without suffering a significant number of casualties. Ludtke was very taken with this site and painted a beautiful landscape with the bridge in the foreground. Among his many paintings are *Little Round Top, South of Gettysburg, Pebble Beach #9, Fall Shore, Springs of Tapatio* (Tapatio is a golf resort in San Antonio), *Fall at Tapatio, Treasury of Athens,* and *Pilar Church* (the church is in Buenos Aires, and Ludtke's granddaughter's name is Pilar).

Ludtke worked from photographs that he had taken and used two unusual tools to help him create the images on canvas: a pallet filled with burnt umber and a roll of paper towels on his workbench. Burnt umber is a medium-brown pigment made by heating umber, which is a dark brown clay containing oxides of iron and manganese. It is often used for oil and watercolor paint, but Ludtke did not use it specifically as a color but rather as a way of etching out the lights

and darks. He would take a sheet from the paper towel roll, dip it into turpentine, then thin the burnt umber and begin painting using only the towel. He squinted to focus on the shadowing, and if he wanted to lighten the darks, he used a little more turpentine, ever so lightly. He would often remind Erik, who also took up painting, to "always paint dark into light." He used the towel to move paint around, blot, and blend. For Ludtke, the paper towel was an integral tool. Shapes and images would appear, and the scene on the canvas would come to life. If he was not pleased with the way the image was taking shape, he would take a paper towel dipped in turpentine, remove all the paint, and start over.

In about ten to fifteen minutes, the initial image would be in place, and Ludtke would then come in with the paintbrushes—always using warm colors, blending, and again painting light over dark. His creativity, sense of light and color, manual dexterity, and soft touch all came together, allowing him to find a well-deserved release by creating art in a completely different medium.

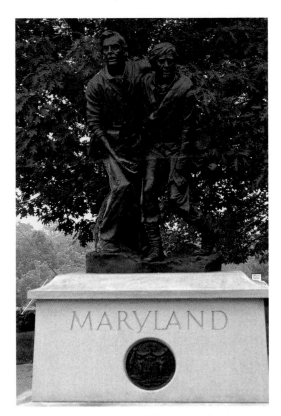

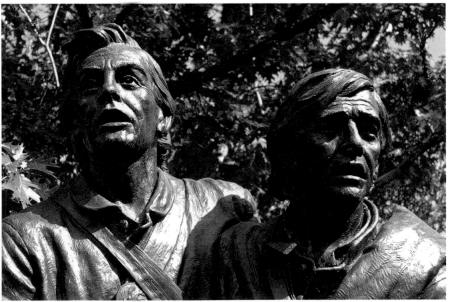

Brothers Again, Gettysburg National Military Park. Courtesy of Jaroslav Vodehnal.

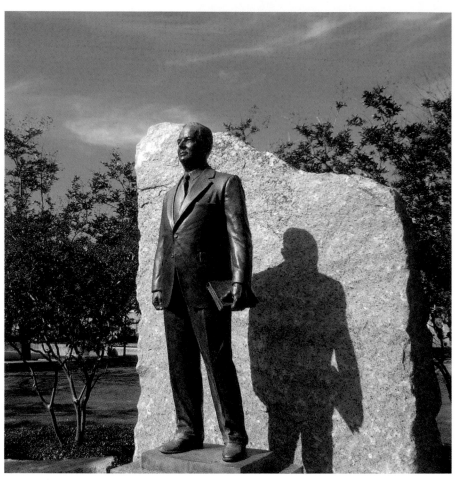

James Earl Rudder, Texas A&M University. Courtesy of Jaroslav Vodehnal.

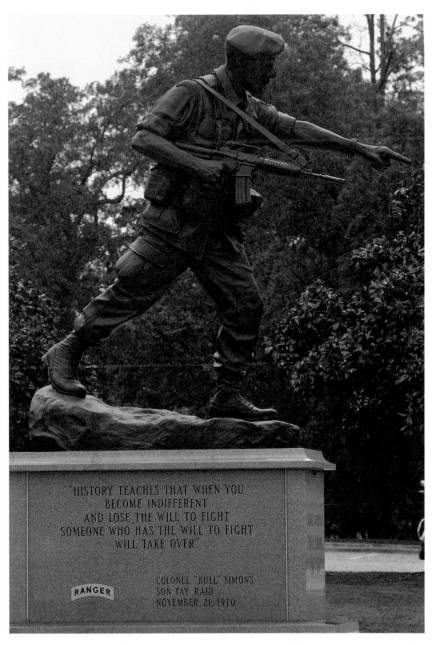

Col. Arthur D. "Bull" Simons, John F. Kennedy Special Warfare Center and School, Fort Bragg, NC. Courtesy of Ludtke family.

Pietà, Saint Mary's Seminary, Houston. Courtesy of Ludtke family.

Tribute to Texas Children, State Capitol, Austin, TX. Courtesy of Jaroslav Vodehnal.

ARCH 406, Texas A&M University. Courtesy of Jaroslav Vodehnal.

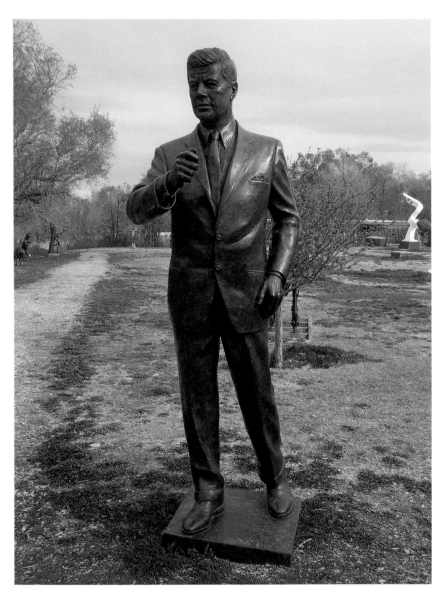

John F. Kennedy, Fort Worth. Courtesy of Shidoni Foundry.

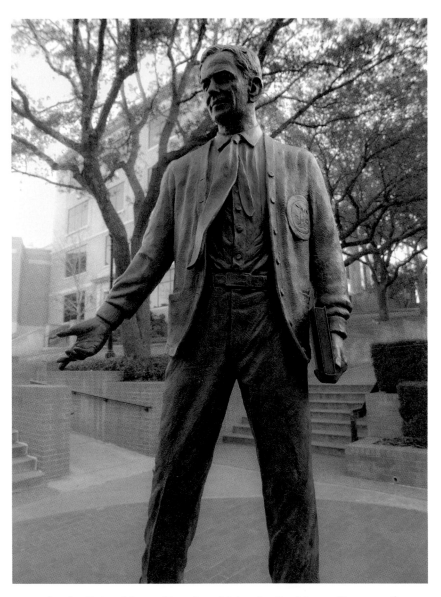

Lyndon Baines Johnson, Texas State University, San Marcos. Courtesy of Jaroslav Vodehnal.

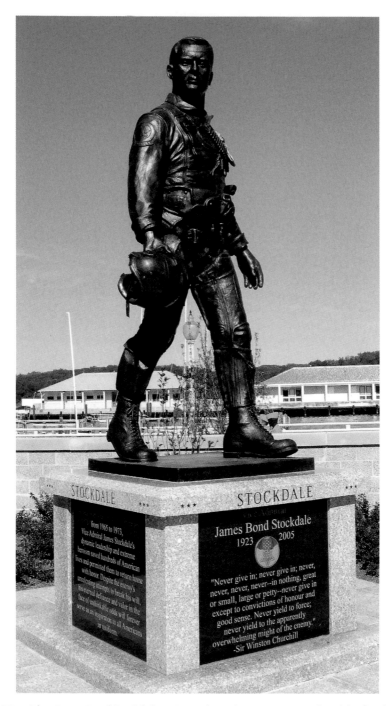

STOCKDALE *** STOCKDALE

from 1965 to 1973,
Vice Admiral James Stockdale's
dynamic leadership and extreme
heroism saved hundreds of American
lives and permitted them to return home
with honor. Despite the enemy's
unrelenting attempts to break his will,
his eternal defiance and valor in the
face of unthinkable odds will forever
serve as an inspiration to all Americans
in uniform.

Vice Admiral
James Bond Stockdale
1923 2005

"Never give in; never give in; never,
never, never, never--in nothing, great
or small, large or petty--never give in
except to convictions of honour and
good sense. Never yield to force;
never yield to the apparently
overwhelming might of the enemy."
-Sir Winston Churchill

Vice Adm. James Bond Stockdale, US Naval Academy. Courtesy of Ludtke family.

Texas Ties

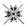

IN HIS BELOVED STATE OF TEXAS, Ludtke's reputation as a classical sculptor continued to spread, and he received numerous commissions from universities, hospitals, nonprofits, private entrepreneurs, and various organizations. In her book *A Comprehensive Guide to Outdoor Sculpture in Texas,* author Carol Morris Little writes that Ludtke was "one of the state's best known portrait and figurative sculptors," with his works appearing in cities such as Houston, San Antonio, College Station, Austin, San Marcos, Amarillo, San Angelo, and Sulphur Springs.[1] From Houston's Reliant Park to the state capitol grounds in Austin, Ludtke's works pepper the Lone Star State.

In 1995, Ludtke received a commission from the Houston Livestock Show and Rodeo to create a bronze to be displayed in Carruth Plaza, located between the Reliant Astrodome and Reliant Stadium. Carruth Plaza has since become a western art sculpture garden, and it is where Ludtke's bronze of a proud young woman stands. Entitled *Yes!,* the eight-foot figure of a young female in Wrangler® jeans and wearing a ponytail is punching the air with a first-place ribbon grasped in her hand. The young woman depicted has just been given the coveted award for her livestock entry, and Ludtke wanted to show the exuberance and joy she feels after meeting the challenge. She punches the sky as if to say, "Yes, I've done it!" Ludtke took numerous photographs of young exhibitors at the 1993 rodeo, and he saw that "whether they were riding or showing calves, they were all ultimately seeking the blue ribbon." It is the first bronze of a woman in the collection, which includes eight other pieces,

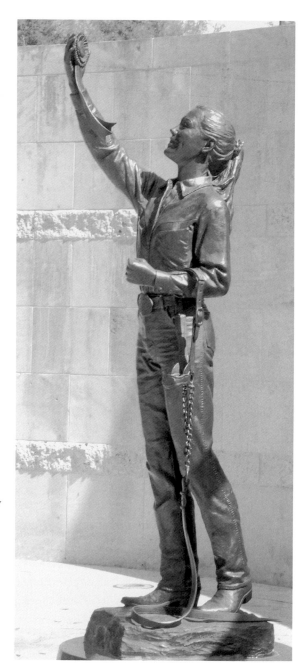

Yes! sculpture commissioned by the Houston Livestock Show and Rodeo. It is the first female bronze in the western art sculpture garden at Carruth Plaza between Houston's Reliant Stadium and the Astrodome complex. Courtesy of Jaroslav Vodehnal.

several by Houston artists.[2] Other Houston landmarks also display his commissioned work, including two bas-relief panels of Jesse Jones and his nephew, John Jones, at Jones Hall and larger-than-life portrait busts of Albert Alkek and his wife at the Alkek Hospital wing of MD Anderson Cancer Center.

Since 1998, visitors approaching the grounds of the state capitol in Austin from the north side encounter six life-size bronze children who appear to be making their way to the same historic pink-granite building. Ludtke was awarded the commission to create *Tribute to Texas Children,* which depicts six children on a field trip to the Texas capitol, each one reflecting the excitement and vibrancy of youth. Coordinated by the Texas Elementary Principals and Supervisors Association and the Texas Association of Secondary Principals, this statewide project involved schools, classes, and individual children raising $190,000 for the sculpture, which was the first statue to be placed on the capitol's grounds since 1951.[3] Ludtke used child models that represented the ethnic diversity of Texas, and he later took great pride in watching youngsters run up to touch and hug the statues. Their reactions fulfilled his hope that the pieces would "show that statues don't have to be stuffy but can celebrate youth and life."

Throughout his time as a sculptor, Ludtke did only commissioned work and showed little interest in entering the exhibit or show circuit, where many national sculptors feature their work. Therefore, he was not as well known among his peers as one would imagine given the quality of his work and reputation. However, a fellow sculptor, Paul Moore, remembered first seeing a Ludtke piece in *Sculpture Review* magazine. It was a photo of the *Sam Houston* sculpture at SeaWorld, and Moore was quite taken with it, particularly the cape. Moore ran the enlarging studio at Shidoni Foundry for a while before embarking on his own distinguished sculpting career, and he eventually got to know Ludtke pretty well through his work at the foundry. He described Ludtke as the ultimate "sculptor's sculptor," meaning he was the type of sculptor who was driven by his love of sculpting and doing quality work—rather than merely engaging in showmanship.[4] For Ludtke, sculpting was not about money or recognition. It was about his love and passion for classical sculpture and the Old World techniques. All of these components came together when he created a portrait sculpture, and Moore believed that "there were few in the

Ludtke working on the clay model of the face of a young girl.
Courtesy of the Ludtke family.

United States who were as gifted as Larry in doing so." Moore and renowned sculptor Veryl Goodnight affirmed that a Ludtke piece is distinguished by the emphasis on the profile and anatomy being absolutely perfect. Ludtke was a stickler for correct proportions, following the guidelines for dimensions and proportions to use in human forms that were put forth by renowned sculptor Edouard Lanteri (1848–1917) in his book *Modelling and Sculpting the Human Figure*. Likewise, Ludtke had a gift for accurately portraying the gravity pull on a figure (or balance of the torso) and the delicate tooling of hands. He did wonderful, precise hands, and it was often this part of the piece, along with the face, that provided the sense of vitality in his standing figures. Ludtke's technique of pulling the clay, rather than pushing it, and using his fingers to make many, many short strokes created an active surface texture—detailed, yet not overworked.[5]

As more and more requests came in for commissioned work, Ludtke often had to find the time to balance his multiple projects, but he always stayed true to his character and business principles. He was always up front about

how long it would take him to finish the project and "get it right." Typically, Ludtke estimated one month for the creation of a working clay model, or maquette, for the client's approval of the design. Once given the go-ahead, he would spend about four months building the armature and modeling the full-size piece. The armature was absolutely crucial in producing quality work. Although many might view the armature as just a contraption of twisted rods and metal, sculptors like Ludtke knew that it was the foundation for a sculpture, essential for both creating and holding the weight of the piece. As for modeling, he always did his own model of the full-size piece. As Ludtke stated in one proposal, "I do not give small incomplete models of my work to enlargers employed by the foundries to have the model blown up and in essence, do my work for me. I don't believe in it. When a client gets my work, it will be mine and not work done by some sculptor employed by a foundry."[6] He put just as much effort and detail into presenting the finished life-size model to the client as he did when creating the actual piece. He contemplated the presentation for hours, working on positioning the piece in just the right spot in his studio, determining how much lighting should be used, and figuring out where he should stand while the client studied the sculpture. All of this was extremely important to Ludtke.

Once given the final approval, Ludtke allotted five to six months for moldmaking, casting, finishing in bronze, preparation of the base or pedestal, and delivery to the client or specified site. His primary moldmaker after Cesare Contini was Brad Neighbor of New Mexico. Ludtke and Neighbor worked extremely well together, and Ludtke was so pleased with his work that he told him, "Brad, as long as I've got work, you've got the molds." Neighbor fondly remembered Ludtke being the quintessential storyteller as he supervised the entire process in his studio. He spent a great deal of time at the foundry inspecting the next steps of the wax modeling. He truly valued this part of the process because it gave him an extra stage of refinement. As Neighbor pointed out, "Some artists are 'hands off' once the mold is completed, but for classically trained artists, such as Larry, the wax copy from the mold gave him an extra opportunity to further refine his work."[7] If something was not quite right with the wax model, Ludtke required that it be fixed, but he never conveyed his requirements in a rude or arrogant manner. At Shidoni Foundry, Ede Ericson

Ludtke working with a plaster cast in his studio. Courtesy of Brad Neighbor.

Cardell always observed a "two-day Ludtke rule," knowing that after he saw the wax model in person or in photographs, he would have to think about what was "off." Typically, it was fingers, emblems on uniforms, or perhaps just a little something wrong in the glint of the eye. Two days later, Ludtke would call, and Cardell knew what was about to happen when he began the conversation with "Now, Ede. . . ." She recognized immediately that he had found something. "He'd call and say, 'Now, Ede, when I was looking at that, I'm not so sure, could you measure the distance between X and Y and then tell me what it is?' We'd measure, and it would be off by like an eighth of an inch because sometimes shrinkage happens in the process, but we would fix it immediately for Larry." Even when Ludtke would do the final inspection and give the okay, Cardell still would not let anything go through until at least two days later, just in case. She knew how important the attention to detail was for him. In her opinion, it was not about Ludtke and his perfectionism but that "he was

doing it for his audience—he knew what they expected and he wanted it to be right for them in every way."[8] When the foundry received the final go-ahead, Ludtke also would supervise the final chasing and finishing of the bronze, as well as the application of the patina. He was a very "hands-on" sculptor, and it showed in the minute details of his work. If one wanted a Ludtke piece, he or she knew that the professionalism and the quality of the work would far exceed all expectations when the final product was presented.

Back in Texas, Ludtke was busily creating artwork for display at several of the state's institutions of higher education. Already well represented at Texas A&M University, he was commissioned to sculpt a life-size figure of Joseph D. Jamail and a bust of Harry M. Reasoner for the Jamail Pavilion at the University of Texas School of Law, and both works were dedicated in 2003. After graduating from the law school, the two Houston attorneys became devoted philanthropists who generously supported the university and the law school. Also for the University of Texas, Ludtke created another eight-foot figure of Jamail and one of legendary Longhorns football coach Darrell K. Royal, and both of those statues were placed at the southeast corner of the University of Texas football stadium in 2004. In September 2006, a sculpture of a young Lyndon Baines Johnson was unveiled at Texas State University–San Marcos. Ludtke had been commissioned by the Associated Student Government at the university to create this piece depicting Johnson as he would have looked when he was a student in 1930. Ludtke had already sculpted a Johnson piece for the Texas Walk at SeaWorld in the late 1980s, but this particular sculpture would depict him at a much younger age. Since Texas State is the only Texas university to have graduated a US president and vice president, the students believed it was important to honor Johnson, its most famous alumnus.[9] Ludtke captured Johnson's youthful exuberance, depicting him as if he were on his way to class, holding a textbook, wearing a collegiate sweater, his tie moving with the wind.

Just a few years before creating the sculpture for Texas State University, Ludtke had the privilege to sculpt the likeness of Johnson's White House predecessor, John F. Kennedy. He was commissioned to create the piece by a new organization called the John F. Kennedy Museum Foundation for placement in a downtown Fort Worth plaza. The night before the tragic assassination,

President Kennedy had stayed at the former Texas Hotel (now the Hilton) in downtown Fort Worth. At this hotel Kennedy also delivered his last public speech, at a Fort Worth Chamber of Commerce breakfast just hours prior to his ill-fated Dallas visit. The Kennedy Museum Foundation, which planned to build a permanent museum designed to honor Kennedy, wanted to incorporate the statue in their plans, but several issues kept the project from moving forward. Ludtke was forced to keep the clay model of Kennedy in his studio for nearly nine years.[10] On more than one occasion, Reynolds saw Ludtke become so frustrated with the delays that the sculptor wanted to destroy the clay model by ripping it loose from the armature.

Fast forward seven years, and the Kennedy statue was finally on its way to having a permanent home. Downtown Fort Worth Initiatives, Inc. (DFWII), and the city of Fort Worth acquired the sculpture (now cast in bronze) through private donations and announced plans to renovate General Worth Square and place the statue on the one-and-a-half-acre site as part of the development. The eight-foot statue was intended as the centerpiece of an interpretive exhibit. General Worth Square encompasses the former Texas Hotel, where Kennedy not only gave his last public speech on the morning of November 22, 1963, but also, unexpectedly and unannounced, stepped outside the hotel to greet thousands who had gathered in a parking lot in hopes of catching a glimpse of the president. He then made an impromptu speech in the rain to the crowd of nearly eight thousand people. Andy Taft, president of DFWII, was instrumental in reviving the concept of having the Kennedy sculpture as part of downtown Fort Worth's public art. He, along with city officials and philanthropists Taylor and Shirlee Gandy, believed the piece would be an integral part of telling the larger story of Kennedy and of Fort Worth's significant place in the history of his fateful trip to Texas.[11]

Although Ludtke's monumental figures of military heroes, political figures, famous Texans, sports legends, and other prominent individuals are his most widely known pieces, Texas is also home to two religious sculptures that he created early in his career, and both have a deep sense of personal emotion, as well as historical significance. In 1966, Ludtke created a piece that was dedicated as an outdoor sculpture in the gardens of Saint Mary's Seminary in Houston. He created his *Pietà* depicting Mary, mother of Jesus Christ, sitting on the ground

and holding her dying son in her arms. In Ludtke's sculpture, Mary's face is contorted in painful anguish as she screams over the death of her beloved son, wanting to hold his broken body against her breast just one last time. Ludtke's *Pietà* reveals the horror and terrible sorrow Mary must have felt when holding the lifeless body of Jesus after he had been crucified. Other pietàs typically show Mary in a very stoic pose, peacefully cradling the body of Christ. Ludtke, however, felt that deep within himself lay the need to have this piece "showing Mary as she actually would have been the moment they removed Jesus from the cross and brought him to her—engulfed by grief and utter despair." When creating the piece, Ludtke was drawn into Mary's pain, and even when talking about the sculpture, a deep spiritual connection was revealed in his words. The piece clearly had a profound impact on his life.

Another religious piece that carries great historical significance for the sculptor is *Christ and Child,* in the foyer of Travis Park United Methodist Church in San Antonio. He completed the sculpture in 1980, and it depicts a modern-day young girl sitting on the lap of Jesus Christ, reaching up to touch his long hair with her small hand. The piece was commissioned by a couple whose young daughter had died, and they wanted to have a sculpture created in her honor and memory. The couple did not want the child's face to look exactly like their daughter, fearing it might be too painful to see her image every Sunday, so Ludtke insisted they not send any photographs of her. Instead, he chose as his models two girls about seven to eight years old— one from the Travis Park church in San Antonio who closely resembled the deceased daughter and the other a neighbor's little girl in Houston. In order to get the proportions and sizing right, Ludtke took measurements of the girl in the church's congregation, and when he was back at his studio, the neighbor's daughter, who was about the right size, was the model for the detail. He also had his neighbor, the girl's father, pose as Christ, because "fortunately he had a wonderful beard."

Ludtke sculpted the piece from the perspective that this girl had gone into Jesus' arms and would be with him forever. The sculpture also suggests that all who come to Jesus do so in a childlike state. When the parents came to Ludtke's studio and saw the finished sculpture of the child and Jesus, with his arms open and waiting, "they looked at each other and began to cry, recognizing

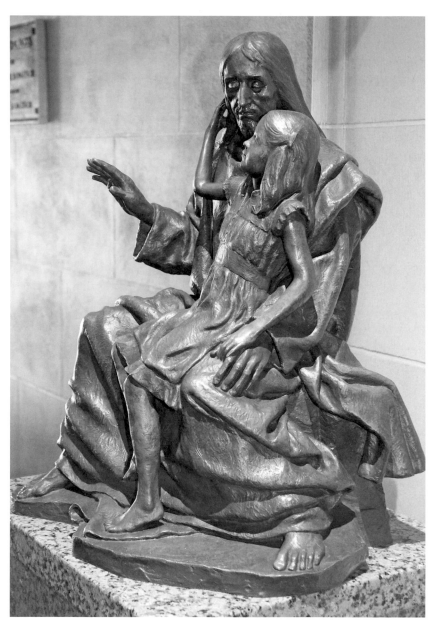

Ludtke's *Christ and Child* at Travis Park United Methodist Church in San Antonio, Texas. Courtesy of Jaroslav Vodehnal.

in some way that it did look so much like their daughter." As Ludtke remembered, "The couple wondered how I could intuitively feel that that was their daughter. It just all came together so beautifully."

The minister of the church had originally contacted Ludtke's mentor, Waldine Tauch, to see if she would be interested in creating the piece. Tauch declined but insisted that Ludtke be the sculptor. In a unique twist of fate, Ludtke's sculpture sits in the very same foyer as a Tauch sculpture entitled *Mother and the Christ Child* and a piece by Tauch's own master, Pompeo Coppini, entitled *Christ Chasing the Money Changers from the Temple.* The works of three generations of Texas' finest classical sculptors sit across from one another, all having been sculpted from the same soft plastilina clay—the clay handed down from the master to his protégé and on to her most promising student.

A Monumental Relationship
between Patriots

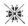

WHEN ASKED FOR THE NAME of one of the most influential people in his life, Ludtke would say, without a doubt, it was the unique friendship he maintained with Texas billionaire Ross Perot. Perot commissioned Ludtke to create numerous sculptures that honored men of valor who served in the US military, many of whom endured tremendous hardships as prisoners of war in Vietnam. These bronze testaments to courage and honor each represent a unique life and story that Perot trusted Ludtke to tell with the utmost respect and authenticity through his sculpture. The two men shared a mutual respect for one another and a deep patriotism that lay at the heart of their working relationship and long-standing friendship.

In the 1970s, Perot commissioned Ludtke to create a four-foot sculpture that would represent the inaugural Risner Award, given annually to the outstanding graduate of the United States Air Force Weapons School. It was named in honor of James Robinson "Robbie" Risner, a legendary air force pilot and former POW at the "Hanoi Hilton" in Vietnam, and Perot had become acquainted with him in 1973 as part of Operation Homecoming, when more than 150 American POWs returned to the United States. In 1999, Perot again commissioned a work from Ludtke, this time to create a heroic-size bronze statue of Risner for the Air Gardens of the Air Force Academy. The large nine-foot piece is symbolic of the episode in which Vietnamese guards seized Risner to place him in solitary confinement as punishment for organizing a religious service among the POWs. When being hauled away, Risner's fel-

low prisoners sang the "Star-Spangled Banner" and "God Bless America," and Risner said that at that moment, "I felt like I was nine feet tall and could go bear hunting with a switch."[1]

Twenty years after the Risner Award commission, Perot had not forgotten about the exceptional quality of work Ludtke produced, and he again enlisted the sculptor's help to create another heroic image, this one of Maj. Richard "Dick" Meadows. Meadows was a legendary special operations officer who was the key planner and assault team leader for the Son Tay raid in Vietnam. This raid was an attempt to rescue American prisoners of war held in a camp near Hanoi. Over the years, Meadows had earned the reputation of being a courageous and trusted special operations advisor willing to oversee dangerous missions. Even after his retirement, he served as a clandestine operative in Tehran, Iran, assisting in an attempted rescue of American hostages. Unfortunately, the mission failed, and Meadows had to find a way to escape his position deep inside Iran.[2] Perot wanted to honor Meadows's character and heroism by having a statue placed at the US Army Special Operations Command headquarters at Fort Bragg, North Carolina. Meadows's wife, Pam, provided Ludtke with excellent photographs of her husband, while his son, Mark, pulled together all the authentic clothing and equipment and then served as the sculptor's model. Ludtke depicted Meadows in a classic pose—advancing as if into a clearing, somewhere behind enemy lines, with his CAR-15 ready on semi-automatic in his right arm. The piece was dedicated in 1997, and Ludtke was thrilled to create the Meadows statue. As with all of his military figures, he took painstaking efforts to make sure he had every detail perfectly accurate. Given that the sculpture depicts Meadows on a mission, he is not wearing a hat (Meadows did not like wearing one) nor is there any insignia or indication of rank or army unit on the uniform. All the metal pieces on the outfit are covered as they would be during a clandestine operation so as not to reflect any light. One of the Son Tay raiders, Joseph W. Lupyak, a retired command sergeant major, confirmed that Ludtke had gotten the sculpture right. "It's an exact likeness. It's unbelievable. It looks just like Dick," he noted.[3]

In 1998, Perot offered Ludtke an opportunity to create a statue of Col. Arthur D. "Bull" Simons, the Green Beret legend who also led the Son Tay raid in Vietnam. After a distinguished military career, Simons was enlisted by

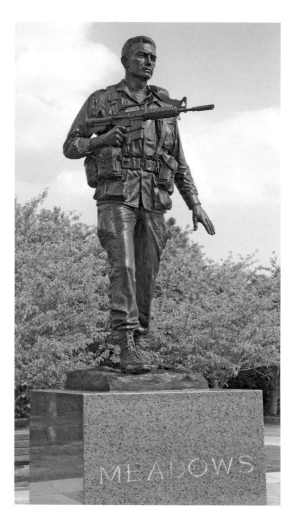

Ludtke's sculpture of Maj. Richard "Dick" Meadows stands at the leading edge of the Meadows Memorial Parade Field, just outside the US Army Special Operations Command headquarters at Fort Bragg, North Carolina. Courtesy of Jaroslav Vodehnal.

Perot to lead a mission to free employees from Perot's company, Electronic Data Systems (EDS), who were being held prisoner in Iran just prior to the Iranian Revolution. The mission was a success and is retold in Ken Follett's book, *On Wings of Eagles*.[4] Ludtke extensively researched Simons and could not have sculpted a more detailed, precise likeness of the hero—from the authentic uniform, complete with its various patches, to the ring on his finger and watch on his arm. The twelve-foot sculpture shows Simons in an action pose, holding a

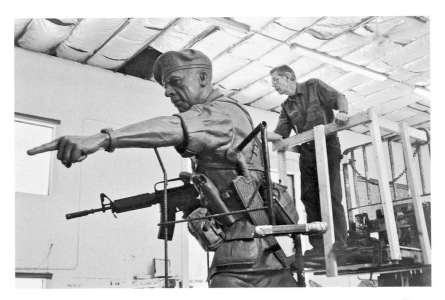

Ludtke on a scaffold observing work on his sculpture of Col. Arthur D. "Bull" Simons at Shidoni Foundry in Santa Fe, New Mexico. Courtesy of the Ludtke family.

rifle in one hand and pointing ahead with the finger of the other. The impressive statue is truly larger than life and is such a befitting depiction of a man who had so much character, spirit, and valor. Interestingly, both of the Risner sculptures, as well as the Simons sculpture, have the same biblical inscription on their bases. The verse alludes to the service these men were willing to give and the sacrifices they were willing to make for their country: "Whom shall I send, and who will go for us? Here am I. Send me" (Isaiah 6:8). To Perot and Ludtke, those words perfectly encapsulated the heroic deeds and willingness to sacrifice offered by these remarkable men.

The thirty-year relationship between Perot and Ludtke was one built upon mutual respect for each other as both professionals and patriots. When Perot was looking for someone to create the first sculpture of Robbie Risner, he did not want merely a statue; he wanted a "person." Mutual friends were behind their first meeting, and once Perot had reviewed Ludtke's portfolio, he had a sense that the sculptor would do "an excellent job with a military sculpture because he was good at getting the strength right." He admired the fact

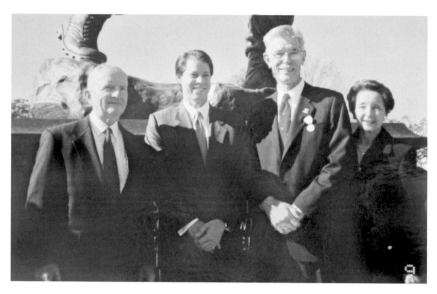

H. Ross Perot, Erik Ludtke, Lawrence Ludtke, and his wife, Erika, at the dedication ceremony for the statue of Col. Arthur D. "Bull" Simons in 1998. Courtesy of the Ludtke family.

that Ludtke never did anything to promote himself but rather was a "humble man of absolute integrity intent on getting the mission accomplished." Ludtke exhibited a driven work ethic, always wanting to make sure everything looked precisely as it should, down to the most minute detail. As Perot noted, "I could trust him completely and never had to spend a second worrying about Larry." Perot had found his man in Ludtke—the right person and the right fit to create these monumental pieces. What particularly gave Perot and Ludtke such great joy was when the families and fellow soldiers of these heroes visited the sculptures and they were overwhelmed by the amazing accuracy and attention to detail. For Ludtke, the relationship with Perot was "one that comes along once in a lifetime." He enjoyed working for Perot because he knew Perot wanted only the best, insisting on the highest quality. Each of the sculptures commissioned by Perot presented unique challenges, but Ludtke relished the opportunity to provide his best work.[5]

Perhaps what Perot found to be so intriguing about Ludtke's sculptures was that the end result always reflected how much the sculptor put his heart and

soul into each piece—a heart and a soul filled with love of country and admiration for American heroes. A devoted friend and supporter of the American military, Perot became legendary for his patriotism. In Ludtke, he found the perfect complement. As Ludtke once said, "Anytime you are drawn to doing a hero, you have to really have a genuine feeling for those people." His respect for these subjects was obvious in his sculptures, particularly in the strength and pride he brought to the figures. Ludtke's patriotism intrinsically guided his hands, helping him bring a human spirit to the surface of the clay. He once wrote, "It has been my intention always to create meaningful work of a heroic nature that would honor the accomplishments of great men and women. I wanted to create work that would be of historic significance and stand the test of time. In all my portrait sculpture my concern is to capture the humanity and character of the subject, not just a likeness. Just a likeness of the subject is not enough. Without soul, the work is nothing."[6]

Ludtke appreciated any opportunity he was given to sculpt the heroic men and women of the military because he so admired their selflessness, spirit, and valor. When he did extensive research on a particular hero, met that individual, or worked with the heroic individual's family and fellow soldiers, his patriotism would be stoked even more. He would completely immerse himself in each hero's life story. To be commissioned by Perot, one of the most patriotic men in America, was a dream come true for him. It was a challenge to which he rose and that he met, every time.

The final two pieces that Perot commissioned Ludtke to create were ten-foot sculptures of Vice Adm. James Bond Stockdale and Vice Adm. William P. Lawrence. These two sculptures stand across from one another at the United States Naval Academy, Perot's alma mater. Stockdale and Lawrence were decorated naval heroes who served six years as POWs in the "Hanoi Hilton" in North Vietnam. Once again, Perot wanted the sculptures to serve as a reminder of the importance of honor and outstanding leadership to the next generation of officers who would graduate from the academy.[7] He called upon Ludtke to create the two pieces, and with great enthusiasm, the sculptor took on the projects. The statues were dedicated in 2008, each evoking the patriotic spirit and character of these two heroes, skillfully sculpted from a clay imbued with Texas history by a man who once pitched baseballs for a living.

Epilogue

ON MAY 4, 2007, Ludtke died after a long, gallant fight against cancer. At his memorial service, family and friends gathered to celebrate his extraordinary life, his remarkable contributions to art and history, and, perhaps even more importantly, to honor the tremendous influence he had on each one of their lives. They remembered this gentle giant of a man who was a renowned sculptor and artist but above all a true southern gentleman and patriot. As Ross Perot eloquently wrote in a letter read at the service, "I would like to remind all of you here today that the last line of the 'Star-Spangled Banner' is a question—'O say does that star-spangled banner yet wave o'er the land of the free and the home of the brave?' As long as we have great patriots like Larry Ludtke, the answer will be a resounding YES."[1]

In a fitting twist of fate, Perot's commissioned sculpture of Vice Adm. William P. Lawrence was Ludtke's last. He was unable to complete it entirely before his death, but Ludtke's good friend and protégé, Paul Moore, assisted with the piece, putting the finishing touches on the head, face, and parts of the uniform. Moore commented that it was a seamless step "because of the amazing work Larry had done on the maquette."[2] Before the piece was cast in bronze, the staff at Shidoni Foundry came up with a unique and moving way to honor the sculptor and pay tribute to his remarkable legacy. Before the bronze was poured, some of his ashes were placed in the sculpture—the perfect resting place for a man who loved being a sculptor.

Ludtke's life journey and his character had as much to do with him being

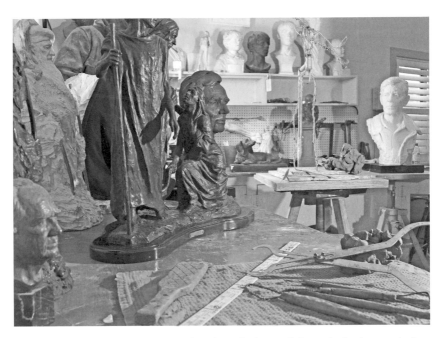

In the foreground, Ludtke's classical tools are laid out while, in the background, clay models and sculptures line the walls of his studio. Courtesy of Jaroslav Vodehnal.

a distinguished sculptor as his specific techniques and tools did. All of his life experiences joined together to further develop and refine this artist's true essence, which ultimately emanated from his sculptures. Ludtke's genuineness and integrity were as authentic as the detailed weapons and emblems he sculpted on many of his military figures. His friend and fellow sculptor Veryl Goodnight points out that his statues, particularly his male military heroes and historical figures, have power and strength—"a real maleness . . . that reflects that they were done by a strong and honorable man."[3] This sense of honor and clear focus translated into sculptures that were very much "alive." Ludtke was so astute at reading people, seeing their gestures, and perfecting the head placement that this observational skill translated into an ability to perfectly capture personalities. Many artists can do a likeness, but Ludtke was able to sculpt manifestations of the subject's soul. He never just sculpted a person or a thing. He went beyond creating an image; he was telling a story,

feeling the emotions involved in that story, and then writing it with his hands into the clay. The end result was a sculpture exuding a true sense of humanity and spirit. As Ludtke once said when describing his philosophy on sculpture, "The ability of the sculptor to model a soul into clay is the true measure of the timelessness of sculpture. I have endeavored to place that soul into each piece I have created over the years. The viewers of the sculpture may never know the quiet music of the creation of sculpture that brings a piece to life. But, they will stop and view the sculpture with respect if it has those intangibles of soul and artist's integrity within."

In some ways, it seems as if Ludtke was from an era long forgotten. He was a true southern gentleman who, not surprisingly, looked to the past to guide him in the figurative sculpture process. He emphasized that, "for me, doing sculpture the Old World way was more important than getting it done or the getting the money. I don't care about all that. That is not the primary purpose in my sculpture. It is more than that. It's the authenticity. It's the line of history of how to do sculpture properly. It's following the procedures that have been followed forever." Ludtke received pure joy from doing his sculptures in the manner of Rodin and Coppini, employing the same techniques that had been passed down for centuries. Using the same clay that was used to sculpt so many historical figures, heroes, and memorials across the Texas landscape, he followed that tradition and left his own mark with nearly a hundred sculptures across the state and the nation. This tradition, coupled with Ludtke's innate character, made him a remarkable sculptor. His skillful working of clay, made permanent in cast bronze, continues to draw an observer in to marvel over the authenticity, the detail, and the emotion of each piece. Ultimately, it connects them with the human spirit found within figurative sculpture.

The Major Sculptures

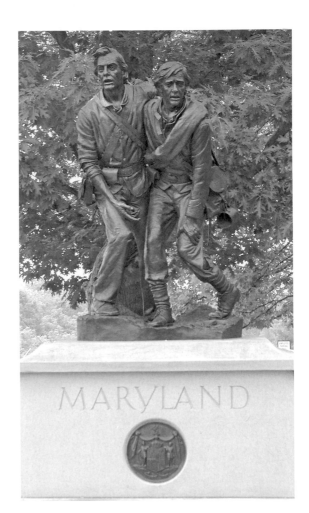

Brothers Again, Gettysburg National Military Park. Courtesy of Jaroslav Vodehnal.

Brothers Again also appears in the color section, following p. 56.

Brothers Again

On the hallowed ground of the Gettysburg battlefield, more than thirteen hundred sculptures and monuments pay tribute to those fallen soldiers of one of the fiercest battles of the Civil War. One of Ludtke's most poignant pieces and one that held a special place in his heart is *Brothers Again,* the Maryland state memorial, which graces this landscape where the fate of a nation hung in the balance. As Ludtke recounted, "I never dreamed when I began my

career as a sculptor it would lead to this ground where so many men fought for causes they were willing to die for. I thought I had come along too late in my career. To have my work placed beside those great sculptors of the past, such as Gutzon Borglum, Bush Brown [Henry Kirke Bush-Brown], and Donald DeLuc, was a challenge and a responsibility not taken lightly."

The Maryland state memorial alludes to the fact that during the Civil War Maryland was a border state and there were Marylanders among both the Union and Confederate troops at the battle of Gettysburg. Brother fought against brother, and childhood friends engaged in battle from opposite sides. Ludtke's piece depicts two uniformed men, one Union soldier and the other a Confederate soldier, both of whom are weary and wounded, leaning on each other for support as they walk from the field of battle at Culp's Hill. Both are hatless and without any weapons. "The reason I left the weapons behind them," Ludtke noted, "is because I didn't really want to glorify war with this sculpture, but rather peace and a sense of moving on with their lives, putting the war behind them. It is evident that they both fought hard, as their cartridge boxes and cap boxes are open, showing they are spent physically and

emotionally." Ludtke did not want either man in a dominant position nor did he want them looking at each other. Rather, he "wanted them to be looking out, away from the battlefield, toward the future—toward something more than the hell they'd just been through."

In the stillness of the night following the sculpture's dedication in 1994, Ludtke and his dear friend Jim Reynolds went back to the Gettysburg site to see the piece one more time and reflect. Ludtke reached up, not choosing to touch one soldier over the other, but rather placed his hand on the common ground they shared.

Sam Houston

When recalling the pieces that meant the most to him over the thirty years of doing sculpture, Ludtke unequivocally mentioned the likeness of Gen. Sam Houston he created for SeaWorld's Texas Walk. "*Sam Houston* is so dear to my heart," recalled the sculptor, "because ever since I was a kid, when I thought of heroes, I thought of Sam Houston."

Houston is one of the most colorful figures in the history of Texas and is revered as a major hero in the state. The general and president of the Republic of Texas stood more than six feet tall and was noted in his day for having an impressive speaking voice, as well as a "noble brow and fierce eye."[1] He moved to Texas in 1832 following a period of time when he lived with the Cherokee Indians, and he ultimately became a prominent player in the affairs of Texas. He was elected commander-in-chief of the Texas armies as they battled for independence from Mexico. After the fall of the Alamo and the massacre in Goliad, Houston took control of the forces that soon defeated Santa Anna at the Battle of San Jacinto in 1836. His victory in what was his only major battle became legendary because it freed more than 260,000 square miles of territory. He was elected the first president of the Republic of Texas, later served as a US senator from Texas after it achieved statehood in 1845, and became governor of Texas in 1859.

In Ludtke's larger-than-life sculpture, standing seven feet tall, one can truly sense the heroism, determination, and flair that Houston exuded throughout his life while serving his state and country. Ludtke wanted to pay respect to

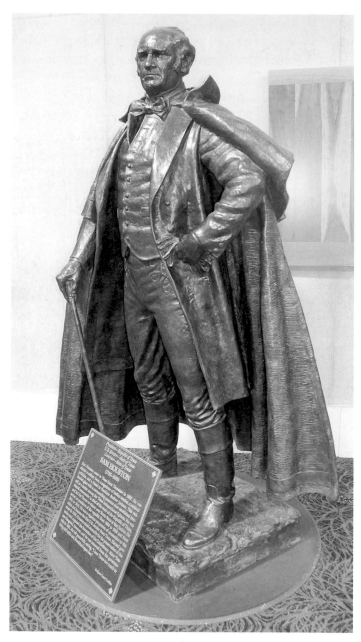

Sam Houston. Courtesy of Jaroslav Vodehnal.

him in a way that elevated his stature and revealed his panache. The cape that he made was an incredible challenge to construct but is the focal point of the piece. Ludtke recalled that the cape was such "a big undertaking in terms of moldmaking and casting that it took almost eighteen months to go from clay to bronze." When it was all said and done, the cape weighed approximately six hundred pounds.

In 2000, SeaWorld removed the Texas Walk from its park and donated the sculptures to the city of San Antonio after Anheuser-Busch, Inc., took over Harcourt Brace Jovanovich as the parent company of SeaWorld. The *Sam Houston* sculpture, along with all the statues from SeaWorld's Texas Walk, were moved to the second-floor lobby of the Henry B. Gonzales Convention Center in San Antonio.

Brig. Gen. James Robinson Risner

Brig. Gen. James Robinson "Robbie" Risner is considered one of the quintessential ace fighter pilots in the history of the United States Air Force, and his image has been memorialized in bronze several times—all by Ludtke, who perceived the opportunity as one of his highest honors. Risner flew 108 missions in Korea and more than fifty in Vietnam, many of which resulted in stories of Risner's tenacity, valor, and selflessness. Often flying aircraft that had been hit and crippled, leading men to safety, and flying at low altitude to locate missile sites and take out their radar, Risner earned the Air Force Cross for his heroic exploits, and he was featured on the cover of *Time* magazine. His last mission resulted in his capture by the North Vietnamese after he ejected into the Gulf of Tonkin. He was imprisoned in the POW camp called the "Hanoi Hilton" and spent many years in solitary confinement in a bamboo box.

Ross Perot met Risner during Operation Homecoming, when more than 150 American POWs returned home. Risner's story inspired Perot, who wanted to do something that grabbed the attention of the four thousand cadets at the Air Force Academy in Colorado Springs and that "motivated and reminded them of what an officer is supposed to be."[2] Perot donated the Risner Award, created in 1976, and the trophy is a four-foot sculpture depicting Risner in his flight suit, holding his helmet in his right arm. Ludtke sculpted a manacle

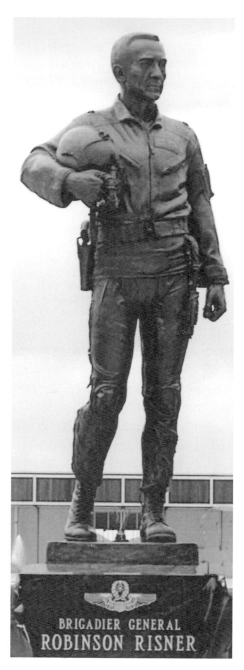

BRIGADIER GENERAL
ROBINSON RISNER

Brig. Gen. James Robinson Risner.
Courtesy of Ludtke family.

chain with a broken link on Risner's left wrist to symbolize that Risner's spirit could not be held prisoner.

An identical casting, also measuring four feet tall, was placed at the USAF Weapons School at Nellis Air Force Base near Las Vegas, Nevada, in 1984. In 1999, Perot commissioned a nine-foot, heroic-size bronze figure, replicating the Risner Award, to be sculpted by Ludtke. The height of this commission symbolized a phrase Risner recalled when describing how he was led off to solitary confinement while his fellow prisoners sang the "Star-Spangled Banner" and "God Bless America." He said that at that very moment, "I felt like I was nine feet tall and could go bear-hunting with a switch." At its 2001 dedication in the Air Gardens at the Air Force Academy, Col. Bud Day, a fellow POW, told the assembled crowd, which included Risner and forty of his fellow prisoners, "For us observers of this event . . . we knew he was, in fact, nine feet tall. This is truly a life-size statue."[3] Later at the event, the men gathered around Risner and sang those two remarkable songs once again.

Christ Head

When Ludtke was doing the preliminary work for the large Risner sculpture, Risner met him in his studio to model for photographs that he would then use in creating the piece. Risner donned an authentic flight suit and then Ludtke photographed him, and his face in particular, from all different angles. When taking the photographs, the sculptor found himself thinking, "After all that Robbie had been through as a POW for seven years, how can anyone appear to be so well-adjusted and happy with himself and life?" Days later, after Ludtke got the prints developed, he laid them out and noticed how the camera froze Robbie's face. "I could then see the hurt lines. I could see things that showed he had great pain at one time, and it was really traumatic to look at it."

Ludtke immediately stopped what he was doing and started to model a small head of Jesus Christ. After about an hour, the sculptor's heart, mind, and hands all came together to capture the underlying pain and suffering that Risner endured, and he transposed it upon the face of Christ. The piece remained part of Ludtke's personal collection and was one of his most

Christ Head. Courtesy of Jaroslav Vodehnal.

cherished works, as he acknowledged how "all of it emanated from Risner and it means so much."

James Earl Rudder

When the name Gen. James Earl Rudder is spoken, many remember the man for his heroic exploits leading a US Army Ranger battalion up the perilous cliffs of Pointe du Hoc along the beaches of Normandy on June 6, 1944. Yet, for more than a decade, General Rudder paved another difficult path: the transformation of Texas A&M from an all-male military college to the vast, world-class university it is today. Serving as its president from 1959 until his death in 1970, Rudder opened up the college to women, changed the name from Texas Agricultural and Mechanical College to Texas A&M University, and made participation in the Corps of Cadets voluntary.

Ludtke and A&M officials thought it was fitting to depict Rudder in a business suit as president of the university, rather than in uniform as a decorated general, particularly since, as A&M's president, he was faced with difficult challenges and an uncharted future. The statue is designed as if he is "walking across the campus," according to Ludtke, "but I did want to somehow honor Rudder's military heroism at Normandy." He envisioned smaller granite blocks framing the piece, while also having a large block serving as a backdrop to the sculpture since that type of stone resembled the rugged, craggy cliffs of Pointe du Hoc. Ludtke, along with Jim Reynolds, director of A&M's Memorial Student Center at the time, and the late Dick Conolly '37, an A&M graduate who led the effort to get funding for the piece, all traveled to Marble Falls in Central Texas to search for the perfect pieces of rough granite from the quarry there. The three men traipsed through two hundred acres of cut granite, and, after a while, Reynolds called out, "I think I've got it!" as he rocked back and forth on a giant, thirty-ton slab of granite. Ludtke recalled, "It was the perfect shape for Pointe du Hoc."

After Ludtke had prepared his full-size clay model of Rudder, Reynolds escorted Margaret Rudder to Larry's studio to view the work-in-progress. As they walked in, the dark clay statue loomed more than seven feet over them. Reynolds recalled, "Margaret looked up at the statue of General Rudder and

James Earl Rudder, Texas A&M University. Courtesy of Jaroslav Vodehnal.
James Earl Rudder also appears in the color section, following p. 56.

literally collapsed back into my arms."[4] Ludtke remembered it being "the single most gratifying moment to see how someone would react to a piece like that." When she looked at it one last time before she left, the sculptor was amused when she walked up to the Rudder sculpture, touched it, and said, "Earl, this was your last chance to lose that weight you were always talking about, and so I asked Larry early on if he would do that, and he did that for me."

Col. Arthur D. "Bull" Simons

Standing at the front of the John F. Kennedy Special Warfare Center and School at Fort Bragg, North Carolina, the imposing twelve-foot statue of Col. Arthur D. "Bull" Simons depicts the Green Beret legend leading his men into

Col. Arthur D. "Bull" Simons, John F. Kennedy Special Warfare
Center and School, Fort Bragg, NC. Courtesy of Ludtke family.

Col. Arthur D. "Bull" Simons also appears in the color section,
following p. 56.

action during the Son Tay raid in Vietnam. The impressive sculpture, funded
by Ross Perot and dedicated in 1998, has become one of the center's most cher-
ished memorials and was one of Ludtke's favorite pieces.

In creating this piece, Ludtke was truly inspired and in awe of the heroic
life and actions of this man. Simons was the epitome of courage and service to

one's country, and he was a larger-than-life figure and thus befittingly depicted in this monumental bronze. He was a dynamic leader in the special forces community, having been handpicked to be the ground commander of Operation Ivory Coast, the joint special operations effort to rescue American prisoners of war from the Son Tay prison in North Vietnam.

The piece itself shows Simons in an action pose and wearing his jungle fatigues, pointing the finger of one hand while holding his rifle in the other. Once again, the sculptor's attention to detail is remarkable, revealing Simons's Smith and Wesson pistol, with handcheckering, in his chest harness, the Special Forces patch, and his ring and wristwatch, as well as his machete in its hand-tooled leather scabbard. The inscription on the base of the piece consists of Simons's own words: "History teaches that when you become indifferent and lose the will to fight, someone who has the will to fight will take over." Ludtke felt a strong connection to this piece and the men whom Simons led. At the statue's dedication, he was awarded an honorary Green Beret and for many years was invited back regularly for the Son Tay Raiders' reunions.

Pietà

Perhaps one of Larry's most moving pieces is the one he created in 1966 of a mother holding her dying son in her arms—her face revealing her sheer despair as she can hardly bear the suffering of losing her child. The mother in the piece is Mary, mother of Jesus Christ, expressing overwhelming grief as it washes over her. Ludtke's *Pietà* reveals the horror and terrible pain Mary must have felt when holding the lifeless body of her son right after he had been removed from the cross. Ludtke noted that, "in the piece, she needed to hold him, there needed to be some moment where she was alone with him, and where she could have some time with him." She is dressed in robes and has a veil on her head while sitting on the ground with the crucified Jesus in her arms. Her back is slightly arched as she leans back and cries out in agony.

Ludtke created the piece early in his sculpting career, and it was dedicated as an outdoor sculpture in the gardens of Saint Mary's Seminary in Houston. The sculpture was given in appreciation of Monsignor Gilbert F. Pekar and donated by Howard Sampley.

Pietà, Saint Mary's Seminary, Houston. Courtesy of Ludtke family.
Pietà also appears in the color section, following p. 56.

Ludtke's *Pietà* is a moving demonstration of the depth of emotion that an artist can feel in being drawn so far into Mary's pain. As Ludtke recalled, "I felt about making the pietà as if it was something that I had contained within me for so long. I brought myself to think just solely of that piece as I worked on it—a piece dominated by Mary, who is carrying the weight of Christ."

Tribute to Texas Children

When thousands of schoolchildren disembark from tour buses near the north lawn of the state capitol in Austin, they may notice that there are six children who appear to be on a field trip and making their way toward the same historic building. Yet, as much as it looks as if these children are running toward

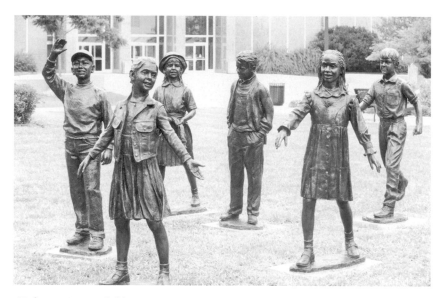

Tribute to Texas Children, State Capitol, Austin, TX. Courtesy of Jaroslav Vodehnal.
Tribute to Texas Children also appears in the color section, following p. 56.

the capitol, they are actually six life-size bronze statues, commissioned by the Texas Elementary Principals and Supervisors Association and the Texas Association of Secondary School Principals, sculpted by Ludtke, and placed on the grounds as a tribute to Texas children in 1998.

Ludtke envisioned a tribute that reflected the excitement, vibrancy, and joy of youth, and it depicts a mix of ethnic groups, appropriately reflecting the state's diverse cultures. He chose models from schools in proximity to his studio in Houston and used clothing that would stand the test of time, rather than any trendy apparel. Ludtke did have to contend with unexpected setbacks while working on the project, including a fire at a San Antonio foundry that destroyed three of the six figures he had worked so hard to create.

ARCH 406

Behind the Langford Architecture Center at Texas A&M University is a bronze statue of a young man, along with his devoted dog, seemingly striding

ARCH 406, Texas A&M University. Courtesy of Jaroslav Vodehnal.
ARCH 406 also appears in the color section, following p. 56.

across the campus, on his way to a senior design course, ARCH 406. This remarkable piece is the only collaborative work done by Ludtke and renowned sculptor Veryl Goodnight. Goodnight, a good friend of Ludtke, had been approached to create a piece that would be donated to A&M's College of Architecture in memory of Stephen Moore, a 1973 environmental design graduate. His parents, Joe Hiram Moore, class of 1938, and wife, Betty, wished to have a sculpture that featured their deceased son's likeness accompanied by a sculpture of a golden retriever, their son's constant companion. Given that

Goodnight's expertise centered on horses and other animals, she asked Ludtke if he would be willing to do Stephen's portrait while she sculpted the dog.

Ludtke meticulously studied photographs of the young man and chose to depict him walking while holding on his right shoulder the strap of a backpack that reveals a T-square, a rolled-up paper, and a small book in the pack's zippered pouch. On the third finger of his right hand the figure is wearing a Texas Aggie ring, indicating that he is a senior. His left hand is extended back and down, as if he is making a beckoning motion toward the dog with his thumb and index finger.

John F. Kennedy

With enthusiasm and unbridled optimism as he began preparing for the next presidential campaign, President John F. Kennedy looked forward to his trip to Texas. When he arrived at Carswell Air Force Base in Fort Worth on the night of November 21, 1963, thousands lined the streets to greet him along the route to the Texas Hotel in downtown Fort Worth. The next morning, President Kennedy walked out of the hotel and addressed a crowd of eight thousand who had gathered in an adjacent parking lot, standing in the rain in hopes of catching a glimpse of the president. They were not disappointed, as he began his impromptu speech by saying, "There are no faint hearts in Fort Worth, and I appreciate your being here this morning."[5] The warmth of the audience was obvious as Kennedy, who never once put on a raincoat, reached out to shake hands among a drenched throng of smiling faces, just hours before he made the fateful trip to Dallas.

After nearly nine years taking up one-quarter of Ludtke's studio and looming over him as he created other sculptures, his eight-foot statue of President John F. Kennedy was finally going to a permanent home. Downtown Fort Worth Initiatives, Inc. (DFWII) and the city of Fort Worth acquired the sculpture (finally cast in bronze) through private donations. The organization announced plans to renovate General Worth Square in downtown Fort Worth and place the statue on the site as part of the improvements and to commemorate the city's place in the history of the president's fateful trip to Texas. When Andy Taft, president of Downtown Fort Worth Initiatives,

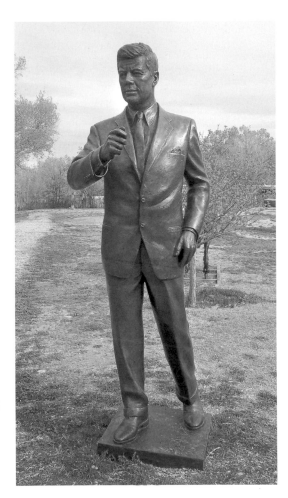

John F. Kennedy, Fort Worth. Courtesy of Shidoni Foundry.

John F. Kennedy also appears in the color section, following p. 56.

Inc., and philanthropists Taylor and Shirlee Gandy had first seen the life-size clay model in the sculptor's studio, it invoked deep emotions. According to Taft, "Larry skillfully captured the power seen on JFK's face, with him leaning forward, conveying the sense of energy and optimism he displayed that very morning in Fort Worth. He was able to accurately depict the president's focus and drive, particularly when looking at how he held his hand with it closed, yet the thumb up. More than just his physical attributes, Larry captured what people saw in JFK—a spirit of hope and internal sense of vitality."[6]

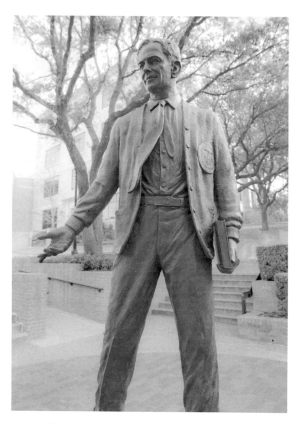

Lyndon Baines Johnson, Texas State University, San Marcos.
Courtesy of Jaroslav Vodehnal.

Lyndon Baines Johnson also appears in the color section, following p. 56.

Lyndon Baines Johnson

The most famous alumnus of Texas State University still seems to stride across the Quad at the San Marcos campus, as if on his way to class. Immortalized in bronze, a young Lyndon Baines Johnson was a student at what was then known as Southwest Texas State Teachers College and received his permanent teaching certificate in 1930. Ludtke depicted him as he might have appeared when he attended, wearing a collegiate sweater and holding a textbook, his tie fluttering in the wind.

The dedication ceremony was held in September 2006 and attracted hundreds of onlookers, university administrators, and guests, including Johnson's daughter, Luci Baines Johnson Turpin and her family. The sculpture was commissioned by the Associated Student Government of Texas State after students of the university voted in a referendum to provide funding from student fees to pay for the project.

Frank Bartley, the student regent on the Texas State University System Board at the time, said the sculptural depiction of LBJ was important because it is important to remember Johnson "as a student rushing through the Quad to a class, worrying about a rent payment that was due, wondering [when] he was going to have the time to study for a history test. It is important to remember that he was once like that, because here on this campus he is more than a chapter in a history book. Here he is personal."[7]

Vice Adm. James Bond Stockdale

When Ross Perot envisioned a sculpture of Vice Adm. James Bond Stockdale, he wanted it to serve as a constant reminder of exemplary leadership for the next generation of leaders to come from his alma mater, the US Naval Academy in Annapolis, Maryland. Stockdale demonstrated the fortitude and grit it took to be not only a fearless test pilot but also a courageous Vietnam POW, held and tortured for seven years in the "Hanoi Hilton." In 1976, the president, on behalf of Congress, awarded him the Medal of Honor. Ludtke's ten-foot sculpture of this war hero, dedicated in October 2008, stands in front of the Naval Academy's Luce Hall, which houses the Stockdale Center for Ethical Leadership.

The sculpture is based on a 1963 photograph that shows Stockdale walking across the carrier flight deck to his airplane. However, as part of the piece, Ludtke included various "touchstones" that held deep meaning for Stockdale and were reflective of his character. One symbol, shown on his flight helmet, is a mathematical graphic depicting infinity and represents an "expression of the boundless pilot moxie he had," according to Sidney B. Stockdale, one of Admiral Stockdale's sons, who spoke at the dedication ceremony.[8] Also, a wristwatch that is only slightly visible, protruding from Admiral Stockdale's flight

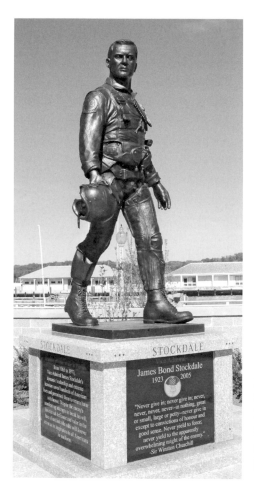

Vice Adm. James Bond Stockdale,
US Naval Academy. Courtesy of
Ludtke family.

Vice Adm. James Bond Stockdale also
appears in the color section, following
p. 56.

suit, represents the watch that his father gave him in the summer of 1943, when
he first reported to the Naval Academy. Stockdale always wore the watch until
the day it was torn away as he ejected from his damaged aircraft over North
Vietnam, suffering major injuries in the process.

After retiring from the Navy in 1978, Stockdale went on to become a dis-
tinguished academic. Perot and Stockdale had such a close friendship that in
1992, when Perot ran for president as an independent, he chose Stockdale as
his running mate.

The following is a generally chronological description of Lawrence M. Ludtke's commissioned sculptures, which are located throughout the United States. Although every effort has been made to include all of the works he created during his vast career, some may have been inadvertently omitted. The formal titles of works of art are normally italicized, but Ludtke rarely provided formal titles for his pieces and instead referred to the majority of them by the names of specific individuals or by general description. For the sake of consistency in the list format below, all the artwork descriptions are in italics.

YEAR	*Title or Description* COMMENT OR LOCATION
1961	*Erik Ludtke* (bust) Ludtke collection; cast aluminum
1963	*Erik* (portrait) Ludtke collection
1966	*Ethicon Ram* Ethicon, Inc., San Angelo, TX
1966	*Pietà* Saint Mary's Seminary, Houston, TX
1973	*Paul Leggett* (life-size bust) Private collection
1974	*E. Riley Leggett* (life-size bust) Private collection
1974	*Kim* (life-size portrait) Ludtke collection
1978	*Brig. Gen. James Robinson Risner* (forty-four inches; Risner Award trophy) Private collection
1978	*Brig. Gen. James Robinson Risner* (maquette size) Private collections
1978 (circa)	*Christ Head* (maquette size) Private collection
1980 (circa)	*Josh Rinq* (maquette-size portrait) Private collection
1980 (circa)	*Wayne Fisher* (life-size bust) Private collection
1980 (circa)	*Erik Ludtke* (life-size portrait) Ludtke collection

1980 (circa)	*Tommy Morris* (life-size portrait) Private collection	
1981 (circa)	*Ralph Samuels* (life-size bust) Water Ski Museum, Winter Haven, FL	
1981	*Martha Beall Mitchell* (life-size bust) Convention Center, Pine Bluff, AR	
1981 (circa)	*Edward Bridges* (life-size bust) Marbridge Foundation, Manchaca, TX	
1981 (circa)	*Mildred Bridges* (life-size bust) Marbridge Foundation, Manchaca, TX	
1982 (circa)	*Christ and Child* Travis Park United Methodist Church, San Antonio, TX	
1982 (circa)	*Emmett LeFlors* (life-size bust) National Cowboy & Western Heritage Museum, Oklahoma City, OK	
1982 (circa)	*Charles Tandy* (life-size bust) National Cowboy & Western Heritage Museum, Oklahoma City, OK	
1982 (circa)	*Anne Burnett Tandy* (life-size bust) National Cowboy & Western Heritage Museum, Oklahoma City, OK	
1982 (circa)	*Col. Leonard B. Scott Jr.* (life-size bust) National Cowboy & Western Heritage Museum, Oklahoma City, OK	
1982 (circa)	*Watt Reynolds Matthews* (life-size bust) National Cowboy & Western Heritage Museum, Oklahoma City, OK	
1982 (circa)	*T. Ross Clement* (life-size bust) National Cowboy & Western Heritage Museum, Oklahoma City, OK	
1982 (circa)	*Walter B. Ludwig* (life-size bust) National Cowboy & Western Heritage Museum, Oklahoma City, OK	
1982 (circa)	*Samuel R. Ratcliff* (life-size bust) National Cowboy & Western Heritage Museum, Oklahoma City, OK	

1982 (circa)	*Elizabeth Shartel Jopling*
	(life-size bust)
	National Cowboy & Western Heritage Museum, Oklahoma City, OK
1982 (circa)	*Leonardo Horse*
	(maquette size)
	Ludtke collection
1984 (circa)	*The Spirit of Ronald Reagan*
	(seventeen and a half inches)
	Ronald Reagan Presidential Library, Simi Valley, CA,
	and Memorial Student Center Texas A&M University,
	College Station, TX
1984–1986 (circa)	*Sam Houston*
	(heroic size)
	Henry B. Gonzales Convention Center, San Antonio, TX
1984–1986 (circa)	*Mildred "Babe" Didrikson Zaharias*
	(heroic size)
	Henry B. Gonzales Convention Center, San Antonio, TX
1984–1986 (circa)	*US Congressman Henry B. Gonzales*
	(heroic size)
	Henry B. Gonzales Convention Center, San Antonio, TX
1984–1986 (circa)	*Astronaut Edward H. White III*
	(heroic size)
	Henry B. Gonzales Convention Center, San Antonio, TX
1984–1986 (circa)	*Howard Robard Hughes Sr.*
	(heroic size)
	Henry B. Gonzales Convention Center, San Antonio, TX
1984–1986 (circa)	*President Lyndon Baines Johnson*
	(heroic size)
	Henry B. Gonzales Convention Center, San Antonio, TX
1985 (circa)	*Maury Maverick Sr.*
	(life-size bust)
	Maverick Plaza, San Antonio, TX
1986	*Gen. Jerome F. O'Malley*
	(half body)
	United States Air Force Academy, Colorado Springs, CO
1987	*Gen. William J. "Wild Bill" Donovan*
	CIA headquarters, Langley, VA
1987 (circa)	*Attorney Wayne Fisher*
	(life-size bust)
	Private collection

1987 (circa)	*Attorney Robert Miller* (life-size bust) Private collection
1988 (circa)	*Charles Luckman* (portrait) Freedoms Foundation, Valley Forge, PA
1988 (circa)	*Leslie Schultz* (portrait) Freedoms Foundation, Valley Forge, PA
1988	*Sam Houston Equestrian* (maquette size) Ludtke collection
1988	*Ernest Hemingway* (maquette size) Ludtke collection
1989	*Bud Adams* (life-size bust) Sigma Chi Foundation, Chicago, IL, and private collection
1989	*Ingenue* (maquette size) Private collections
1989	*Walking Nude* (maquette size) Ludtke collection and private collections
1989	*Moonlight* (twenty-inch image) Ludtke collection and private collections
1989	*Bud Adams's Grandchildren* series (portrait) Private collections
1989	*Gov. John B. Connally* (life-size bust) Lyndon Baines Johnson Presidential Library and Museum, Austin, TX, and Texas A&M University System Administration Building, College Station, TX
1990	*Winds of War* Private collection
1990 (circa)	*Biographies in Bronze* series (small portraits) commissioned by Altermann-Morris Galleries Private collections and some in Ludtke collection

1990	*In Her Care*
	Private collections (fundraiser for Gladney Home)
1990 (circa)	*Nude Torso*
	(silver patina; life size)
	Ludtke collection
1990 (circa)	*American Quarter Horse Association Donors*
	(twenty-two head studies)
	American Quarter Horse Association, Amarillo, TX
1991 (circa)	*Nude Torso*
	(dark patina; life size)
	Ludtke collection
1991 (circa)	*Middleton Son*
	(portrait)
	Private collection
1991	*Granger Family*
	(portraits)
	Private collection
1991 (circa)	*Sam Houston*
	(small portraits)
	Private collections
1991	*Texas Touch*
	(approx. three-inch longhorn steer)
	Private collections
1991	*You Make the Call*
	T. H. Rogers Secondary School (baseball fields), Houston, TX, and private collection
1991 (circa)	*Dagenbella Commissions*
	(small figures)
	Private collections
1991 (circa)	*Unnamed Portrait,*
	commissioned by M. H. Bell
	Private collection
1991 (circa)	*Laurel*
	(life-size portrait) commissioned by Dr. K. Kaesler
	Private collection
1991 (circa)	*Winston Churchill*
	(six-inch portrait),
	commissioned by International Churchill Society
	Private collection

1991 (circa)	*Studio Helpers*
	(maquette size)
	Ludtke collection
1991 (circa)	*Sam Houston*
	(three-and-a-half-inch bust)
	Private collections (Altermann-Morris series)
1992	*Albert B. Alkek*
	(life-size bust)
	Institute of Biosciences and Technology of Texas A&M University, Houston, TX
1992	*President Lyndon Baines Johnson*
	(bust from SeaWorld casting)
	Private collection
1992	*ARCH 406*
	(in collaboration with Veryl Goodnight)
	Texas A&M University, College Station, TX
1992 (circa)	*Henry C. "Ladd" Hitch*
	(life-size bust)
	National Cowboy & Western Heritage Museum, Oklahoma City, OK
1992 (circa)	*Leon H. Snyder*
	(life-size bust)
	National Cowboy & Western Heritage Museum, Oklahoma City, OK
1992 (circa)	*Medal of Honor Recipients*
	(seven bas-relief panels)
	Sam Houston Sanders Corps of Cadets Visitors Center, Texas A&M University, College Station, TX
1992 (circa)	*Delphi Torso*
	(maquette size)
	Private collection
1992 (circa)	*Milan Panic*
	(portrait)
	Freedoms Foundation, Valley Forge, PA
1992	*Dr. Trujillo*
	(life-size bust)
	MD Anderson Cancer Center, Houston, TX
1992	*Day Dreamer*
	Private collections and Ludtke collection
1992	*Dawn*
	Private collections and Ludtke collection
1992	*Solitude*
	Private collections

1993 *Sam Houston*
 (portrait, approx. six and one-half inches, two hundred copies),
 commissioned by Atascosito Historical Society for bicentennial
 of his birth
 Private collections

1993 *Albert B. Alkek*
 (life-size bust), commissioned by MD Anderson Hospital
 Alkek Hospital, MD Anderson Cancer Center, Houston, TX

1993 *Margaret M. Alkek*
 (life-size bust), commissioned by MD Anderson Hospital
 Alkek Hospital, MD Anderson Cancer Center, Houston, TX

1993 *James Earl Rudder*
 Texas A&M University, College Station, TX

1993 *J. Wayne Stark*
 (life-size bust)
 Rudder Auditorium, Texas A&M University, College Station, TX

1993 (circa) *Ball Four*
 (children series; approx. twenty inches)
 Private collections

1993 (circa) *Little Slugger*
 (children series; approx. twenty inches)
 Private collections

1993 (circa) *It's Outta Here*
 (children series; approx. twenty inches)
 Private collections

1993 (circa) *I Got It! I Got It!*
 (children series; approx. twenty inches)
 Private collections and Ludtke collection

1993 (circa) *High Hard One*
 (children series; approx. twenty inches)
 Private collections

1993 (circa) *Turning for Home*
 (children series; approx. twenty inches)
 Private collections

1994 *Yes!*
 Carruth Plaza, Reliant Stadium, Houston, TX

1994 (circa) *Young Sam Houston*
 Private collection

1994 (circa) *Sam Houston with Battle Flag*
 (twenty-three and one-half inches)
 commissioned by City of Houston Art Commission;

project not completed
Private collection (Taste of Texas Restaurant), I-10 West, Houston, TX

1994	*Running Mustang* (maquette size) Private collection
1994	*Brothers Again* (Maryland state memorial) National Battlefield Park, Gettysburg, PA
1994	*Brothers Again* (maquette size) Private collections
1995	*Mr. Jordan* (large bas-relief plaque), commissioned by Houston Industries Reliant Energy Building (formerly Houston Lighting & Power), Houston, TX
1995	*Mr. Sykora* (large bas-relief plaque), commissioned by Houston Industries Reliant Energy Building (formerly Houston Lighting & Power), Houston, TX
1995	*Dr. Martel* (bas-relief) Texas A&M University, College Station, TX
1995 (circa)	*Robert E. Lee* (small portrait) Private collection
1995 (circa)	*Abraham Lincoln* (life-size bust) Ludtke collection
1995	*Maj. Richard J. "Dick" Meadows* commissioned by Ross Perot Fort Bragg, NC
1995	*Mustang* (maquette size for Southern Methodist University) Private collections (major contributor awards for Southern Methodist University)
1995	*Someone Touched Me* Private collection and Ludtke collection
1996	*John T. Jones* (bas-relief) Jones Hall for the Performing Arts, Houston, TX

1996	*Jesse H. Jones Jr.* (bas-relief) Jones Hall for the Performing Arts, Houston, TX
1996	*Lt. Williband Bianca* (bas-relief) South Dakota State University, Brookings, SD
1996 (circa)	*Quest* Private collection
1996	*Tribute to Texas Children* Capitol grounds, Austin, TX
1997	*Paradise Lost* Private collections and Ludtke collection
1997	*Akimbo* Private collection
1998	*Danger 79er* (Gen. James Hollingsworth) Texas A&M University, College Station, TX
1998	*Col. Arthur D. "Bull" Simons,* commissioned by Ross Perot Fort Bragg, NC
1998 (circa)	*Emily* Private collection
1998	*Hollingsworth* (life-size bust from *Danger 79er*) Private collection
1999	*Hopkins County World War II Memorial* Sulphur Springs, TX
1999 (circa)	*Overcash* Private collection
1999	*John F. Kennedy* (maquette) Private collections and Ludtke collection
1999	*Brig. Gen. James Robinson Risner* commissioned by Ross Perot United States Air Force Academy, Colorado Springs, CO
2000 (circa)	*Byron Nelson* commissioned by Georgia Golf Hall of Fame Augusta Botanical Gardens, Augusta, GA

2000	*Rodin* (maquette size) Ludtke collection
2000	*Erika* (life-size portrait) Private collection
2000 (circa)	*Reagan* (life-size portrait) Private collection and Ludtke collection
2001	*Michaela* (life-size portraits of Supkis children) Private collection
2001	*Danielle* (life-size portraits of Supkis children) Private collection
2001	*Max* (life-size portraits of Supkis children) Private collection
2001	*Grip and Rip It* Private collection and Ludtke collection
2001	*Watch This Mom* Private collection and Ludtke collection
2001	*Barbara Radnowski* (life-size bust) Private collection
2002	*Harry M. Reasoner* (life-size bust) commissioned by the University of Texas School of Law University of Texas, Austin, TX
2002	*Joe Jamail* (life-size bust) commissioned by the University of Texas School of Law University of Texas, Austin, TX
2003 (circa)	*Joe Jamail* (three castings) commissioned by the University of Texas University of Texas, Austin, TX
2003	*Gen. Jerome F. O'Malley* (maquette) Private collections (recognition awards)

2003 (circa)	*Darrell Royal*
	commissioned by the University of Texas
	Darrell K. Royal–Texas Memorial Stadium,
	University of Texas, Austin, TX
2005	*Carl T. Morene*
	(bas-relief)
	Schulenberg City Hall, Schulenberg, TX
2006	*Vice Adm. James Bond Stockdale*
	commissioned by Ross Perot
	United States Naval Academy, Annapolis, MD
2007	*Vice Adm. William Porter Lawrence*
	commissioned by Ross Perot
	United States Naval Academy; Annapolis, MD
2008	*John F. Kennedy*
	General Worth Square, Fort Worth, TX
2008	*John F. Kennedy*
	(maquettes)
	Private collections and Ludtke collection

NOTES

INTRODUCTION

1. Donald Martin Reynolds, *Masters of American Sculpture: The Figurative Tradition from the American Renaissance to the Millennium* (New York: Abbeville Press, 1993), 9.

2. Ibid.

3. "Grant in Sculpture: Part I—The Context," http://www.grantstomb.org/news/gis01.html.

4. Pompeo Coppini, *From Dawn to Sunset* (San Antonio: Naylor, 1949); "Coppini, Pompeo Luigi," Texas State Historical Association, http://www.tshaonline.org/handbook/online/articles/fc067; "Founders," Coppini Academy of Fine Arts, http://coppini.us/founders.html.

5. Unless otherwise indicated, all quotations from Ludtke are taken from taped interviews by author, Houston, TX, April 2007.

PAINTBRUSHES AND FASTBALLS

1. John Hollis, "Larry Ludtke: Former Minor-Leaguer a Big-League Sculptor," *Houston Post*, May 9, 1982.

2. "Solis, Ludtke Credited with 3-1, 4-1 Triumphs," *Miami Herald,* no date.

AN AWAKENING

1. Erika Ludtke, interview by author, Houston, TX, April 2007.

2. Ibid.

A GUIDING HAND FROM THE PAST

1. Coppini, *From Dawn to Sunset,* 308.

2. Pompeo Coppini, letter to Bruce W. Bryant, State Superintendent of Public Buildings and Grounds, regarding Lawrence Sullivan Ross statue, Austin, TX, May 8, 1918, Lawrence Ludtke personal collection; Coppini, *From Dawn to Sunset,* 232.

1. Erik Ludtke, interview by author, Houston, TX, April 20, 2007.

2. "Bronze Rams Flank San Angelo Entrance," *Ethicon News,* August 1966.

3. H. Ross Perot, interview by author, Dallas, TX, February 8, 2008.

4. Ibid.; Raquel Rutledge, "Fighter Pilot Robinson Risner," *Colorado Springs Gazette,* November 17, 2001; "General Robbie Risner's 9' Tall Statue," http://www.nampows.org/ Risner.

5. "An Unprecedented Opportunity," Reagan Bronze, Inc., http://www.reaganbronze .com/PAGES/History/html; Ronald Reagan, letter to Lawrence Ludtke, February 24, 1986, Ludtke personal collection.

6. "Donovan's Statue," https://www.cia.gov/about-cia/virtual-tour-flash/flash-movie-text.html.

7. Jacqueline M. Pontello, "The Texas Walk," *Southwest Art,* August 1988, 72–74.

8. Ibid., 74.

9. Lucy D. Rosenfeld, *A Century of American Sculpture: The Roman Bronze Works Foundry* (Atglen, PA: Schiffer Publishing, 2002), 8–13.

10. "Victor M. Contini Is Dead at 81: Translated Visions into Bronze," *New York Times,* October 17, 1995. Victor Contini was the younger brother of Ludtke's longtime moldmaker, Cesare Contini.

RETURN TO AGGIELAND

1. Memorandum from James R. Reynolds to Amy Glass, editor in chief, *Texas Aggie,* May 9, 2003; James R. Reynolds, interview by author, Houston, TX, November 19, 2007.

2. Quoted in Mike L. Downey, "A Legacy in Clay," *Texas Aggie,* January–February 2004, 44.

3. Reynolds interview.

4. Lawrence Ludtke, proposal for James Earl Rudder statue, submitted to R. N. "Dick" Conolly, March 30, 1992, Ludtke personal collection.

5. Quoted in Downey, "Legacy in Clay," 45.

6. Brad Neighbor, interview by author, Santa Fe, NM, November 6, 2007.

7. Reynolds interview; Erika Ludtke interview.

8. Veryl Goodnight, telephone interview by author, November 14, 2007.

9. "First Statue on Quad Honors Hollingsworth '40," *First Call,* Texas A&M University, fall 1999, 5; speech for dedication of *Gen. James F. Hollingsworth* statue, given by Lawrence Ludtke, September 10, 1999.

BROTHERS AGAIN

1. Robert Holt, "Maryland Gettysburg Memorial Dedicated," *Gettysburg Times,* November 14, 1994; Maryland Public Television, *Gettysburg Remembered: This Hallowed Ground* (Owing Mills: Maryland Public Television, 1994), video.

2. Proposal to the Committee for Citizens for a Maryland Monument at Gettysburg, submitted by Lawrence Ludtke, 1992, Ludtke personal collection.

3. O. James "Jim" Lighthizer, telephone interview by author, February 2, 2009.

4. Coppini, *From Dawn to Sunset,* 308.

5. Jaroslav Vodehnal, interview by author, November 12, 2008.

6. Ede Ericson Cardell and Michael Cardell, interview by author, Santa Fe, NM, November 5, 2007.

7. Reynolds interview.

8. Holt, "Maryland Gettysburg Memorial Dedicated"; program for Maryland State Memorial at Gettysburg Dedication Ceremony, November 13, 1994, Ludtke personal collection.

TEE TIMES AND BRUSHSTROKES

1. Adrian McAnneny, telephone interview by author, March 4, 2009; Adrian McAnneny, letter to Ludtke family, May 10, 2007.

2. Vodehnal interview; Erik Ludtke interview.

TEXAS TIES

1. Carol Morris Little, *A Comprehensive Guide to Outdoor Sculpture in Texas* (Austin: University of Texas Press, 1996), 25.

2. Cheryl Laird, "First Female Bronze Statue to Grace Rodeo," *Houston Chronicle,* February 18, 1995.

3. "Tribute Evokes Smiles and Maybe a Moment's Pause," *Classroom Teacher,* summer 1998, 6–7; Lawrence Ludtke, letter to Brad Duggan, executive director, Texas Elementary Principals and Supervisors Association (TEPSA), October 10, 1992, Ludtke personal collection.

4. Paul Moore, telephone interview by author, February 2, 2009.

5. Ibid.; Goodnight interview.

6. Questionnaire completed by Lawrence Ludtke for the American Fine Art and Frame Company, no date.

7. Neighbor interview.

8. Ede Ericson Cardell interview.

9. "Hail to the Chief," *Campus Guide,* Texas State University–San Marcos, spring 2007, 16–17; "Texas State to Unveil LBJ Statue," press release from Texas State University–San Marcos, September 6, 2006.

10. "Artist Sues Memorial Foundation over JFK Statue," *Reporter News Online,* November 24, 2002, http://www.texasnews.com/1998/2002/texas/texas_Artist_su1124.html.

11. Andy Taft, telephone interview by author, May 15, 2009; "Downtown Fort Worth Initiatives, Inc., Request for Proposals for the Provision of Landscape and Architec-

tural Design and Related Consulting Services for the Installation of President John F. Kennedy Statue and Interpretive Exhibit and Improvements to General Worth Square, September 4, 2009; "Project: The JFK Tribute," http://www.dfwi.org/what-we-do/projects/jfk.

A MONUMENTAL RELATIONSHIP BETWEEN PATRIOTS

1. "General Robbie Risner's 9' Tall Statue," http://www.nampows.org/Risner.

2. "The Meadows Statue," US Army Special Operations Command Fact Sheet; Program from Eighth Annual Richard J. Meadows Memorial Scholarship Banquet, August 9, 2003.

3. Lawrence Ludtke, letters to H. Ross Perot regarding Meadows sculpture, August 2, 1995, August 14, 1995, and September 22, 1995; Lupyak quoted in Henry Cunningham, "Perot Helps Honor Special Operator," http://www.sfalx.com/h_meadows_perot_helps_honor_special_operat.html.

4. Ken Follett, On Wings of Eagles (New York: William Morris, 1983).

5. Perot interview.

6. Lawrence Ludtke, letter to Ward Wells, March 23, 2002.

7. Perot interview.

EPILOGUE

1. H. Ross Perot, letter to Ludtke family, June 23, 2007.

2. Moore interview.

3. Goodnight interview.

THE MAJOR SCULPTURES

1. Harper's Weekly, March 30, 1861, http://www.sonofthesouth.net/leefoundation/civil-war/1861/march/sam-houston-biography.htm.

2. Ross Perot quoted in Rutledge, "Fighter Pilot Robinson Risner."

3. Col. Bud Day quoted in Rutledge, "Fighter Pilot Robinson Risner."

4. Reynolds interview.

5. Jeb Byrne, "The Hours before Dallas: A Recollection by President Kennedy's Fort Worth Advance Man, Part 3," Prologue Magazine 32, no. 2 (summer 2000), http://www.archives.gov/publications/prologue/2000/summer/jfk-last-day-3.html.

6. Taft interview.

7. Frank Bartley quoted in "Hail to the Chief," 17.

8. "James B. Stockdale," http://www.medalofhonor.com/JamesStockdale.html; Earl Kelly, "Naval Academy Dedicates Statue of Vice Admiral Stockdale," http://www.hometownannapolis.com/cgi-bin/readne/2008/11_01-25/NAV.

BIBLIOGRAPHY

LAWRENCE M. LUDTKE PERSONAL FILES

All personal correspondence, project proposals, programs for sculpture dedication cere-
monies, journals, lecture notes, and other documents are contained within Ludtke's per-
sonal files, to which the author was given access.

BOOKS, ARTICLES, AND OTHER SOURCES

Allen, Paula. "One-Time Sea World Statues Find Home." *San Antonio Express-News,*
August 30, 2008.

"Artist Sues Memorial Foundation over JFK Statue." *Reporter News Online,* November
24, 2002. http://www.texasnews.com/1998/2002/texas/texas_Artist_su1124.html
(accessed April 18, 2007).

Baigell, Matthew. *A Concise History of American Painting and Sculpture.* New York:
Harper Row, 1984.

Baird, Annette. "Hands-on Endeavor: For Spring Branch Sculptor, Spending Time with
Dignitaries Is an Everyday Experience." *Houston Chronicle,* February 21, 2002.

"Bronze Rams Flank San Angelo Entrance." *Ethicon News,* August 1966.

Byrne, Jeb. "The Hours before Dallas: A Recollection by President Kennedy's Fort
Worth Advance Man, Part 3." *Prologue Magazine* 32 (summer 2000). http://www
.archives.gov/publications/prologue/2000/summer/jfk-last-day-3.html (accessed May
15, 2009).

Coppini, Pompeo. *From Dawn to Sunset.* San Antonio: Naylor, 1949.

"Coppini, Pompeo Luigi." Texas State Historical Association. http://www.tshaonline
.org/handbook/online/articles/CC/fco67.html (accessed March 20, 2007).

Cunningham, Henry. "Perot Helps Honor Special Operator." http://www.sfalx.com
/h_meadows_perot_helps_honor_special_operat.html (accessed April 21, 2007).

Curtis, Penelope. *Sculpture 1900–1945: After Rodin.* Oxford: Oxford University Press,
1999.

"Donovan's Statue." http://www.cia.gov/about-cia/virtual-tour-flash/flash-movie-text .html (accessed April 21, 2007).

Downey, Mike L. "A Legacy in Clay." *Texas Aggie,* January–February 2004, 42–47.

"First Statue on Quad Honors Hollingsworth '40." *First Call,* Texas A&M University, fall 1999.

Follett, Ken. *On Wings of Eagles.* New York: William Morris, 1983.

"Founders." Coppini Academy of Fine Arts. http://www.coppiniacademy.us/founders /html (accessed March 20, 2007).

Gangelhoff, Bonnie. "Western Heritage." *Southwest Art,* March 1999, 49–52.

"General Robbie Risner's 9' Tall Statue." http://www.nampows.org/Risner.html (accessed September 22, 2007).

"Grant in Sculpture: Part I—The Context." http://www.grantstomb/org/news/gis01 .html (accessed March 1, 2011).

"Hail to the Chief." *Campus Guide,* Texas State University–San Marcos, spring 2007, 16–17.

Haurwitz, Ralph K. M. "UT Stadium to Add Statues of Donor, Coach." *Austin American-Statesman,* October 22, 2004.

Hollis, John. "Larry Ludtke: Former Minor-Leaguer a Big-League Sculptor." *Houston Post,* May 9, 1982.

Holt, Robert. "Maryland Gettysburg Memorial Dedicated." *Gettysburg Times,* November 14, 1994.

————. "Sculptor Seeks 'to Reinforce Our Will to Honor Our Heroes.'" *Gettysburg Times,* November 14, 1994.

"James B. Stockdale." http://www.medalofhonor.com/JamesStockdale.html (accessed January 21, 2009).

Kelly, Earl. "Naval Academy Dedicates Statue of Vice Adm. Stockdale." http://www .hometownannapolis.com/cgi-bin/readne/2008/11_01–25/NAV (accessed January 21, 2009).

Keyser, Tom. "Sculpture Conveys Horror of Battle Marylanders at War." *Baltimore Sun,* November 10, 1994.

Laird, Cheryl. "First Female Bronze Statue to Grace Rodeo." *Houston Chronicle,* February 18, 1995.

Little, Carol Morris. *A Comprehensive Guide to Outdoor Sculpture in Texas.* Austin: University of Texas Press, 1996.

Maryland Public Television. *Gettysburg Remembered: This Hallowed Ground.* Owing Mills: Maryland Public Television, 1994. Video.

"On Campus to Stay." *Texas Aggie,* December 1994.

Pontello, Jacqueline M. "The Texas Walk." *Southwest Art* 18 (August 1988): 70–76.

Reynolds, Donald Martin. *Masters of American Sculpture: The Figurative Tradition from the American Renaissance to the Millennium.* New York: Abbeville Press, 1993.

Rosenfeld, Lucy D. *A Century of American Sculpture: The Roman Bronze Works Foundry.* Atglen, PA: Schiffer Publishing, 2002.

Rutledge, Raquel. "Fighter Pilot Robinson Risner." *Colorado Springs Gazette,* November 17, 2001.

Sanders, Bob Ray. "Fort Worth Finally Gives JFK the Tribute He Deserves." *Fort Worth Star-Telegram,* September 19, 2009.

"Sculpture Gardens." *Southwest Art,* July 1997, 32–34.

"Solis, Ludtke Credited with 3-1, 4-1 Triumphs." *Miami Herald,* no date.

"Texas State to Unveil LBJ Statue." Texas State University–San Marcos press release, September 6, 2006.

"Tribute Evokes Smiles and Maybe a Moment's Pause." *Classroom Teacher,* summer 1998, 6–7.

"Trophies . . . When You Want the Very Best." *Sculpture Review* 30 (winter 1981–1982): 16–17, 24–25.

"An Unprecedented Opportunity." Ronald Reagan Bronze, Inc., http://www.reagan bronze.com/PAGES/History/html (accessed April 18, 2007).

Van Eyck, Zack. "Shidoni Casts Memorial with Gettysburg Address." *Santa Fe New Mexican,* November 3, 1994.

Van Winkle, John. "Perot: 'Human Nature Doesn't Change.'" *Academy Spirit,* United States Air Force Academy, March 4, 2005.

"Victor M. Contini Is Dead at 81: Translated Visions into Bronze." *New York Times,* October 17, 1995.

INTERVIEWS BY AUTHOR

Ede Ericson Cardell, November 5, 2007.
Michael Cardell, November 5, 2007.
Veryl Goodnight, November 14, 2007.
O. James "Jim" Lighthizer, February 2, 2009.
Erik Ludtke, April 20, 2007.
Erika Ludtke, April 9–26, 2007.
Lawrence M. "Larry" Ludtke, April 9–26, 2007.
Adrian McAnneny, March 4, 2009.
Paul Moore, February 2, 2009.
Brad Neighbor, November 6, 2007.
H. Ross Perot, February 8, 2008.
James R. Reynolds, November 19, 2007.
Bobby Schlitzberger, February 14, 2009.
Andy Taft, May 15, 2009.
Jaroslav Vodehnal, November 12, 2008.

INDEX

Note: Page numbers in *italics* indicate photographs.

Vietnam War, 26, 44, 68, 83
Vodehnal, Jaroslav "Jari," 48, 52–53

Washington, DC, 6
waste mold process, 23–24
wax modeling, xii, 32, 36, 61–62
White, Edward H., II, 31
White House visits, 27
Wiley Lecture Series, 42–44
Winston Churchill (Ludtke), 42–44, *43*

Winter Leagues Classic, 13
Wood, Bob, 22
work ethic of Ludtke, 71–74
World War II, 15
World War II subjects, 30, 44–45

Yes! (Ludtke), 57–59, *58*

Zaharias, Babe Didrikson, 31, 51
Zuniga, Leo, 31